Paint a watercolour landscape in minutes

TREES, ROCKS and RUNNING WATER

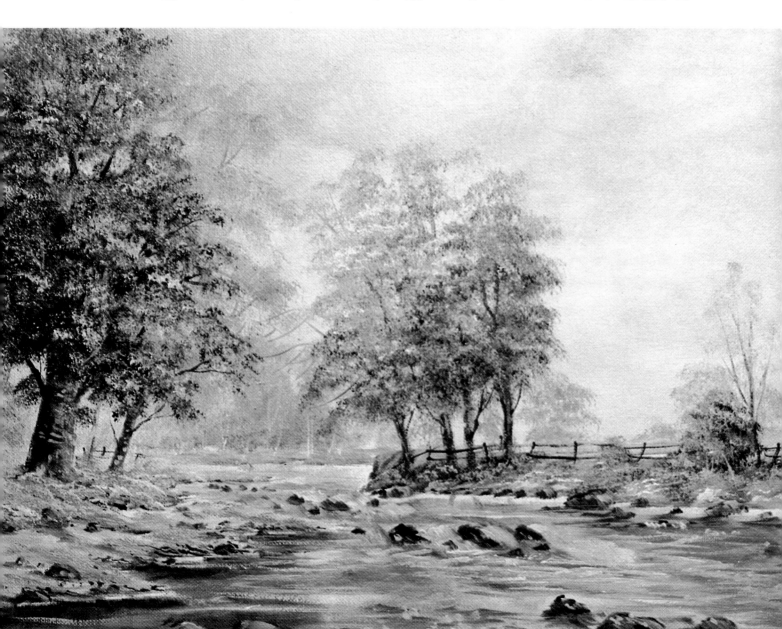

Keith Fenwick

TREES, ROCKS and RUNNING WATER

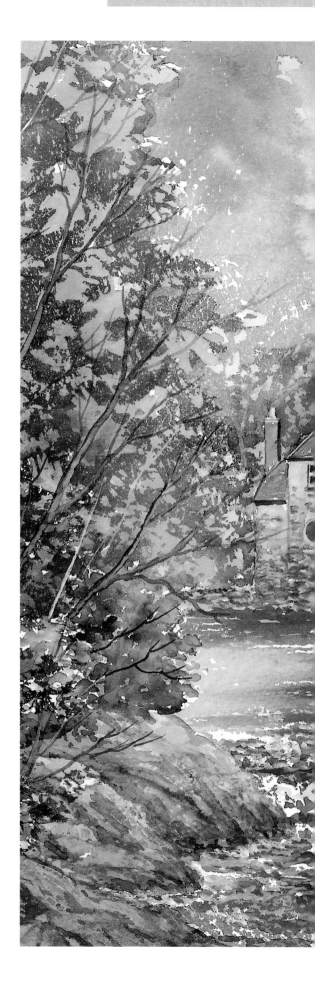

Dedication:

To Dorothy, my wife, for her support, advice and typing of the text, and to all my students over the years whose needs have helped me to determine the content of this book.

Arcturus Publishing
1–7 Shand Street, London SE1 2ES, England

Published in association with

W. Foulsham & Co. Ltd

The Publishing House, Bennetts Close, Cippenham,
Slough, Berkshire SL1 5AP

ISBN 0-572-02834-2

Copyright 2002

Printed in China

WINSOR & NEWTON, COTMAN, FINITY, SCEPTRE GOLD, WINSOR and the GRIFFIN device are trademarks of ColArt Fine Art & Graphics Limited.

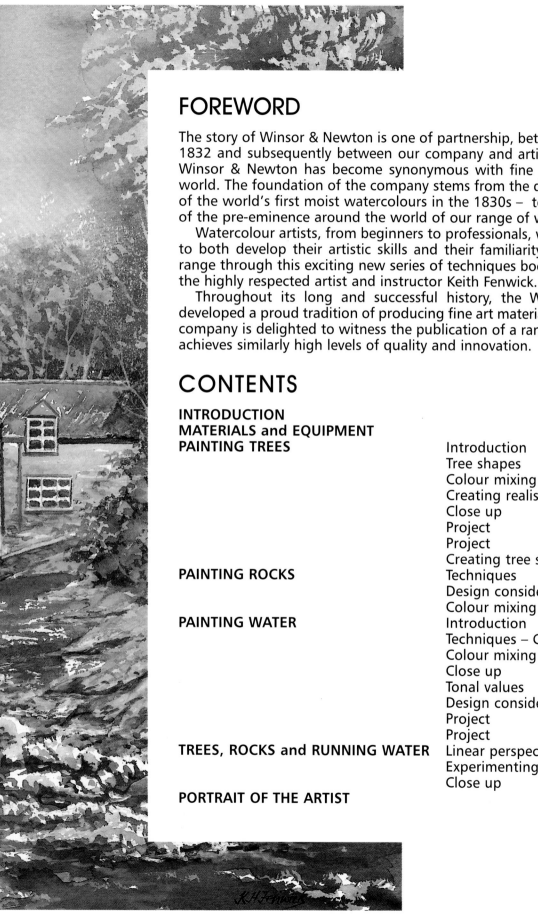

FOREWORD

The story of Winsor & Newton is one of partnership, between our founders starting in 1832 and subsequently between our company and artists. For this reason the name Winsor & Newton has become synonymous with fine art materials throughout the world. The foundation of the company stems from the development and introduction of the world's first moist watercolours in the 1830s – to this day we are justly proud of the pre-eminence around the world of our range of watercolours and materials.

Watercolour artists, from beginners to professionals, will now have the opportunity to both develop their artistic skills and their familiarity with the Winsor & Newton range through this exciting new series of techniques books, written and illustrated by the highly respected artist and instructor Keith Fenwick.

Throughout its long and successful history, the Winsor & Newton brand has developed a proud tradition of producing fine art materials of the highest quality – the company is delighted to witness the publication of a range of watercolour books that achieves similarly high levels of quality and innovation.

CONTENTS

TREES, ROCKS and RUNNING WATER

INTRODUCTION

So you think you can't paint? Well, I say you can. You see, I don't believe painting is a gift. I genuinely believe that anyone can be taught to paint. In this series of books my aim is to show you the wide range of techniques with which I have experimented during over 25 years of painting and teaching. There's an old saying, 'winners never quit, quitters never win'. Whatever we hope to achieve in life, we have to work at it. The same goes for painting. Practise the techniques that I'm going to show you and your confidence will grow.

There's nothing I like better than sitting by a river, listening to the sounds of running water and, if I'm lucky, watching the local 'dipper' bobbing about from rock to rock and diving into the fast-flowing water to catch the resident grubs it feeds on. In this book I'm going to show you several ways to paint trees, how to paint rocks that look real and how to capture the beauty of running water.

Watercolour painting is exciting: unexpected things happen, colours blend together to create wonderful effects. Even if you never reach masterclass level, painting will change your life – ask any artist. Yes, you will make lots of mistakes; we all do. The secret is to understand what has gone wrong and to learn from your mistakes.

Learning to paint is fun, and it's easier than you think. I welcome this opportunity to show you how it's done.

Happy Painting

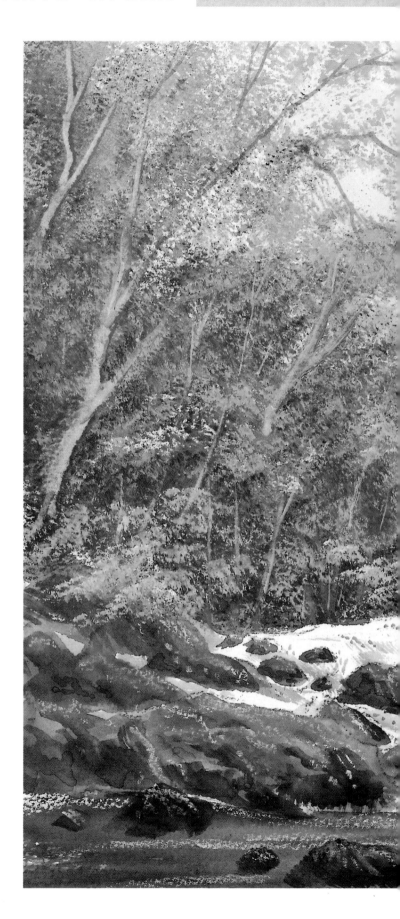

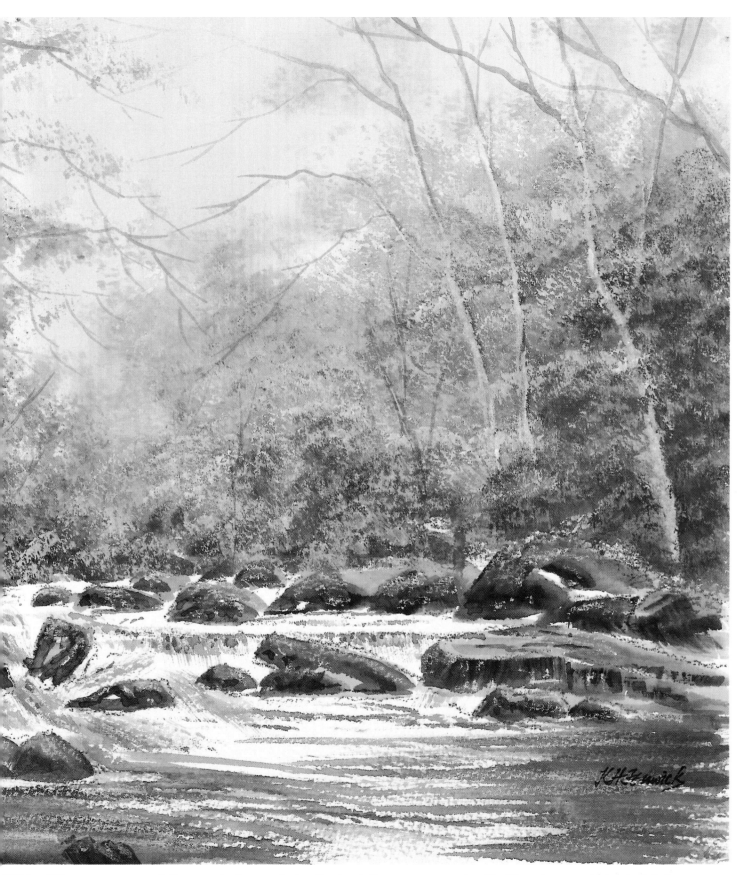

White Water was a scene I discovered when exploring Scotland. I spent a very enjoyable fifty minutes painting it. I left paper uncovered to represent the fast-flowing white water.

A visit to the local art store can be a confusing experience. My preference is to use quality materials, and I would advise you to do the same. Purchase the best you can afford. It will work out cheaper in the long run and save you a great deal of frustration.

PAINTS

Most professional artists prefer tube colours because they are moist and more convenient for mixing large washes of colour. Unless used regularly, pans of paint may become hard and release colour more slowly.

The choice of colours is personal to the artist, but you won't go far wrong if you begin with my basic range, comprising the following:

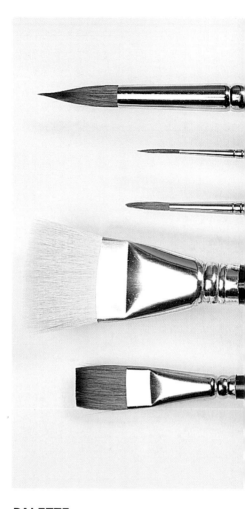

SKIES	EARTH	TREES
Payne's Gray	Raw Sienna	Raw Sienna
Cerulean Blue	Burnt Sienna	Cerulean Blue
French Ultramarine	Cadmium Yellow Pale	French Ultramarine
Indanthrene Blue	Permanent Sap Green	Burnt Sienna
Alizarin Crimson	Gold Ochre	Cadmium Yellow Pale
Winsor Red	Winsor Yellow	Permanent Sap Green
Cobalt Blue	Burnt Umber	Alizarin Crimson
		Payne's Gray

ROCKS	WATER	MIXERS
Raw Sienna	Payne's Gray	Cadmium Yellow Pale
Burnt Umber	Cerulean Blue	Permanent Sap Green
Burnt Sienna	French Ultramarine	Gold Ochre
Alizarin Crimson	Burnt Umber	
Payne's Gray	Alizarin Crimson	

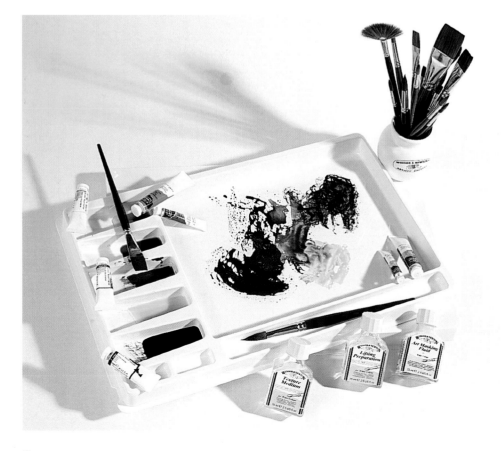

PALETTE

All artists have their own way of painting. I prefer to use a large open palette. I simply draw my colours into the centre of the palette and mix them to my requirements. For large washes I premix colours in saucers. The palette shown includes a lid which provides more than ample space for mixing colours.

BRUSHES

For painting skies and other large areas, I use a 1½in hake brush and for control a size 14 round. For buildings and angular elements, such as mountains and rocks, I use a ¾in flat. For fine detail, such as tree structures, I use a size 3 rigger (originally developed for painting ships' rigging, hence the name), and for detailed work (shadows etc.) I use a size 6 round.

PAPERS

Quality papers come in different forms, sizes, textures and weights. Paper can also be purchased in gummed pads, spiral bound pads, blocks (glued all around except for an area where the sheets can be separated) and in varying sizes and textures.

I prefer to purchase my paper in sheet form (30in x 22in) and cut it to the appropriate size. The paintings in this book are painted on 200 or 300lb rough textured watercolour paper. When sketching outdoors, I use spiral bound pads.

Winsor & Newton offer a choice of surfaces, as follows:

HP (Hot pressed) has a smooth surface, used for calligraphy, pen and wash.

NOT (Cold pressed) has a slight texture (called 'the tooth') and is used for traditional watercolour paintings.

ROUGH paper has a more pronounced texture which is wonderful for large washes, tree foliage, sparkle on water, dry brush techniques, etc. I always use a rough textured paper.

Paper can be purchased in different imperial weights (the weight of a ream [500 sheets] size 30in x 22in):

90lb/190gsm is thin and light and, unless wetted and stretched, it cockles very easily when washes are applied.

140lb/300gsm paper doesn't need stretching unless heavy washes are applied.

200lb/425gsm or 300lb/640gsm papers are my preference.

OTHER ITEMS

The following items make up my painting kit:

Tissues: For creating skies, applying textures and cleaning palettes.

Mediums: Art Masking Fluid, Permanent Masking Medium, Granulation Medium and Lifting Preparation are all useful and selectively used in my paintings.

Masking tape: To control the flow of paint, masking areas in the painting and for fastening paper to backing board. I prefer ³/₄in width as it is easier to remove.

Cocktail sticks: Useful for applying masking when fine lines are required.

Grease-proof paper: For applying masking.

Atomizer bottle: For spraying paper with clean water or paint.

Painting board: Your board should be 2in larger all round than the size of your watercolour painting. Always secure your paper at each corner and each side (8 places) to prevent it cockling when you are painting.

Eraser: A putty eraser is ideal for removing masking.

Sponge: Natural sponges are useful for removing colour and creating tree foliage, texture on rocks, etc.

Water-soluble crayons: For drawing outlines, correcting mistakes and adding highlights.

Palette knife: For moving paint around on the paper (see page 26).

Saucers: For mixing large washes and pouring paint.

Hairdryer: For drying paint between stages.

Easel and stool: I occasionally use a lightweight easel and a stool for outdoor work.

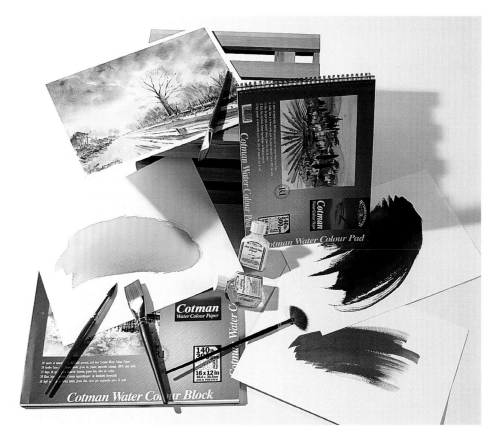

PAINTING TREES *Introduction*

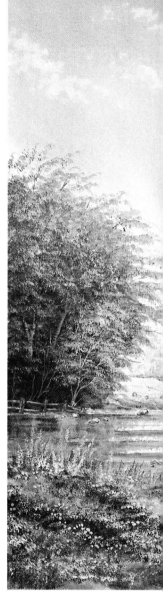

A tree is a living organism that reflects the warmth of spring by growing fresh shoots and leaves. In the autumn it slows down its growth and in many species assumes marvellous autumn tints before shedding its leaves. The evergreens, of course, retain their foliage, providing contrast with their bare deciduous cousins. Each tree displays its own character through its shape.

I spent my childhood playing in acres of mixed woodland. I imagine that's why I love trees and enjoy painting them. You don't have to know the name of a tree in order to paint it successfully, but being able to paint trees that look like trees requires an understanding of basic shape and structure. We'll be looking at these in more detail later.

I get a great deal of enjoyment just from looking at trees. Certainly, careful observation will help you to get your painting of them right. When I'm painting trees I take the following points into consideration:

- Does the structure of the tree look sufficiently sturdy to support its foliage?
- Does the base of the trunk look as if it is capable of supporting the boughs, which support the branches, which support the twigs – each becoming thinner as they reach out from the trunk?
- What is the arrangement of the branches on the boughs? In nature branches rarely grow opposite each other on a bough. Make sure you reflect this in your painting.

The way the brush is used and the fluidity of the paint is most important. In the following pages I aim to show you a wide range of techniques for painting trees and bushes.

The colours I find most useful are shown below.

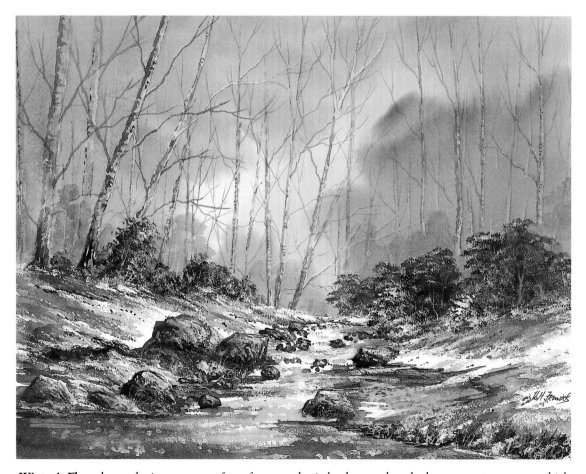

Winter's Flow *shows the importance of a soft atmospheric background to the bare tree structures, which were scratched out with a palette knife. Darker tones were painted on the trunks of the trees to represent texture.*

		Payne's Gray
		Permanent Sap Green
		Cerulean Blue
		Cadmium Yellow Pale
		Raw Sienna
		Burnt Sienna
		Burnt Umber
		Alizarin Crimson

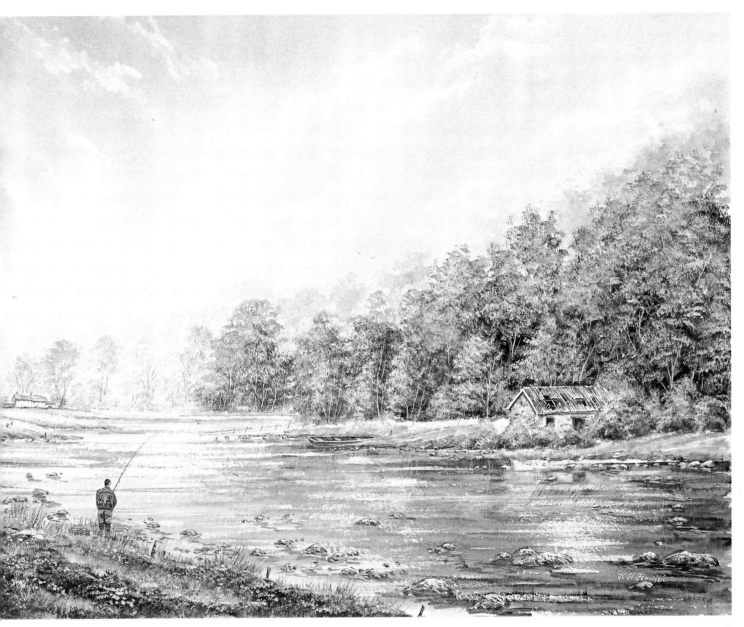

First Catch *was painted in acrylic watercolours. Pale tones were used to represent the distant trees and a variety of tonal values and colours went into painting the groups of trees. It was important to give a rough texture to the bank in the foreground. The red/Sienna roof of the old building contrasts nicely with the green of the trees.*

Points to remember

- If your tree is going to look as though it's growing, it's important to show a diminishing thickness from trunk to bough, and from bough to branch and twig.
- Always leave some gaps in the foliage so that you can paint a few branches showing through. This gives a sense of structure.
- Trees display a variety of tonal values in their foliage.
- Trunks vary in colour between the seasons, from a pale grey to a rich red brown, depending on the particular variety of tree.

- Coniferous trees look the same in summer and autumn – they don't shed their leaves. Deciduous trees shed their leaves and look entirely different when unfrocked.
- Shadows give depth to foliage. Trees look dark on the inside and light on the outside.
- Mature trees weren't planted yesterday, so show some vegetation growing around their base.
- Recession is achieved by painting distant trees with pale cool colours and foreground trees with warm rich colours.

PAINTING TREES *Tree shapes*

Of all the elements in a painting, it's the painting of trees that my students find most difficult. Trees need to be represented convincingly. You don't have to paint them as botanical specimens but as impressions. Structure, tone and colours are what you're going to have to master. Trees can be simplified for painting purposes into three basic shapes: the pyramid, the upturned bucket and the upturned teacup. We'll look at each of these in turn.

Pale washes initially establish the shape of the tree. Darker tonal mixes are added to paint the detail and add depth to the foliage.

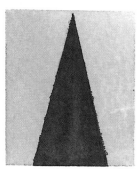

PYRAMID
Examples include:
conifer, spruce,
Lombardy poplar,
fir and pine.

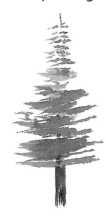
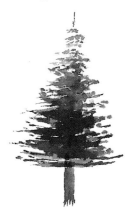

To paint this Norwegian spruce I used a ³/₄ in one stroke brush with an initial pale tone of a Permanent Sap Green/Payne's Gray mix followed by darker tones of the same mix to create depth.

UPTURNED BUCKET
Examples include:
beech, oak, elm,
chestnut, poplar
and ash.

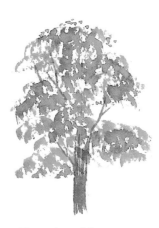
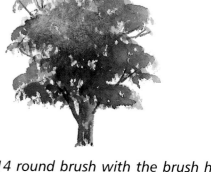

To paint this tree I used a size 14 round brush with the brush held as flat to the paper as possible and the handle virtually horizontal. Short downward strokes, lightly touching the paper, are required.

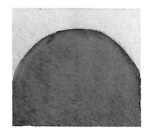

UPTURNED TEACUP
Examples include:
weeping willow,
gorse and bushes in
hedgerow.

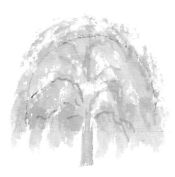
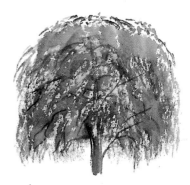

This weeping willow has been painted using identical downward strokes as described above. The shape is very similar but more of a semi-circle.

DESIGN CONSIDERATIONS – EXERCISES

● *Build your understanding of structure by sketching trees when the leaves have fallen.*
● *Choose different tree types – deciduous and evergreen – and paint the same tree in each of the seasons. You will be amazed at the changes you observe.*

● *Practise painting the same tree at different times of the day: early morning, midday and evening. You'll notice significant variations as the light changes. Paint the shadows.*

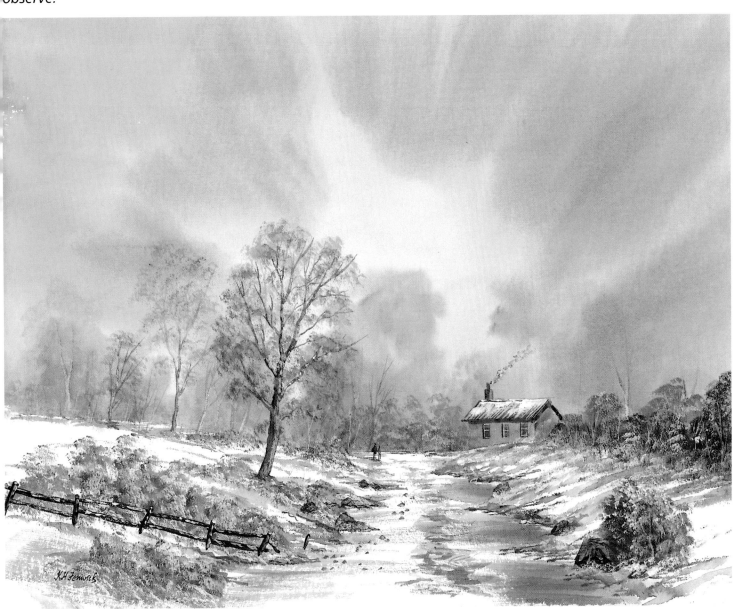

Winter Light, *an acrylic watercolour demonstration to an art society, shows how recession is achieved by painting distant trees wet into wet with minimal detail and painting trees and bushes in the foreground in greater detail.*

Aerial perspective

Trees in the distance should be painted in lighter tones with cooler colours and in less detail. Add warmer and richer colours to trees in the middle distance and foreground. Also include some detailed tree structure. This approach helps the viewer look into the painting.

PAINTING TREES *Colour mixing*

In this section, I want you to practise mixing a wide variety of colours to give you greens and autumn tints for painting foliage. You can also create lovely greys, which will add depth to the trees and bushes you paint. Over 100 shades of green can be produced by mixing combinations of the colours below.

To achieve the correct balance of colour you will need to experiment with mixing colours. The mixes shown here are just some of the variations possible using the colours shown below.

The colours shown opposite are mixes useful for trees at different times of the year.

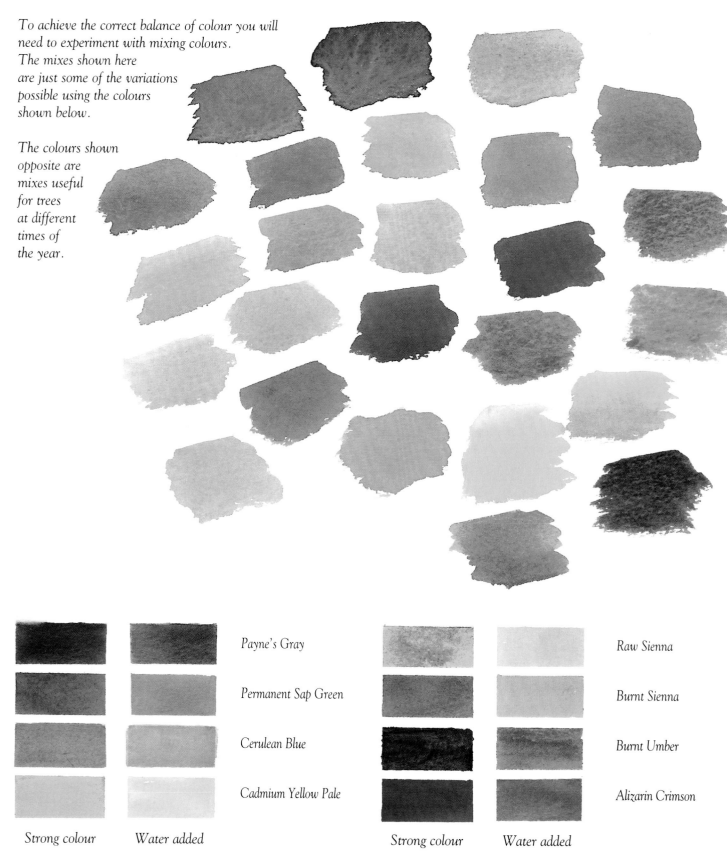

		Payne's Gray
		Permanent Sap Green
		Cerulean Blue
		Cadmium Yellow Pale

Strong colour *Water added*

		Raw Sienna
		Burnt Sienna
		Burnt Umber
		Alizarin Crimson

Strong colour *Water added*

MIXING COLOURS

Practise mixing the following combinations of colours. The quantity of water you use will, of course, determine the depth of the colours.

Soften your greens by adding Raw Sienna or darken them by adding Payne's Gray, Alizarin Crimson, Burnt Umber or Burnt Sienna.

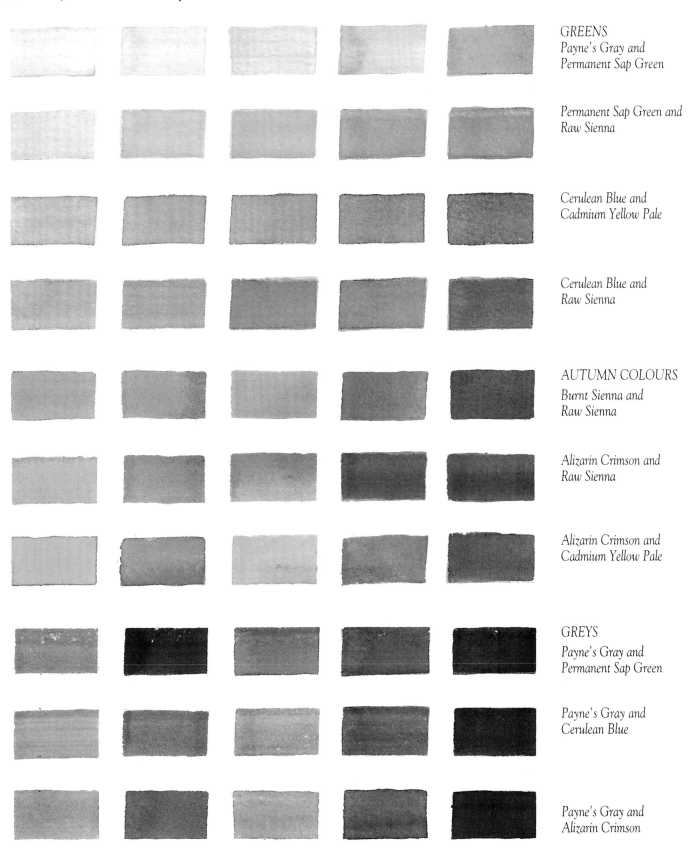

GREENS
Payne's Gray and
Permanent Sap Green

Permanent Sap Green and
Raw Sienna

Cerulean Blue and
Cadmium Yellow Pale

Cerulean Blue and
Raw Sienna

AUTUMN COLOURS
Burnt Sienna and
Raw Sienna

Alizarin Crimson and
Raw Sienna

Alizarin Crimson and
Cadmium Yellow Pale

GREYS
Payne's Gray and
Permanent Sap Green

Payne's Gray and
Cerulean Blue

Payne's Gray and
Alizarin Crimson

PAINTING TREES *Creating realistic foliage*

The inexperienced landscape painter finds great difficulty in representing the foliage on trees and bushes realistically. Here are five simple techniques for you to practise.

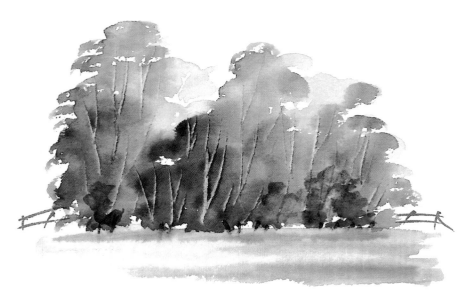

To create this loosely painted group of bushes, I initially loaded a size 14 round brush with pale Raw Sienna and holding it close to the paper, with the brush almost horizontal, I applied a series of quick downward strokes following the shape of the bushes, lightly depositing paint on the paper – see demonstration opposite.

While the paint was still wet I repeated the process, this time with stiffer mixes of mid to dark green colours to give variation and depth to the bushes. I used my thumb-nail to scratch in some structure.

This group of trees and bushes in a hedgerow was painted using an oil painter's round hog-hair brush – see demonstration opposite. Several colours and tones were painted using a stippling action to create a more detailed representation. I used my thumbnail to scratch in some structure; a cocktail stick or corner of a palette knife could be used instead.

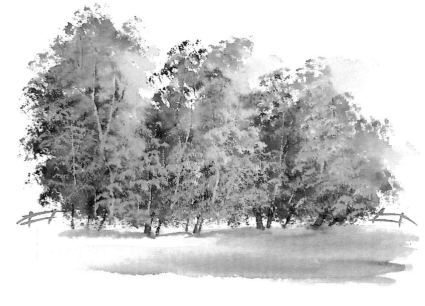

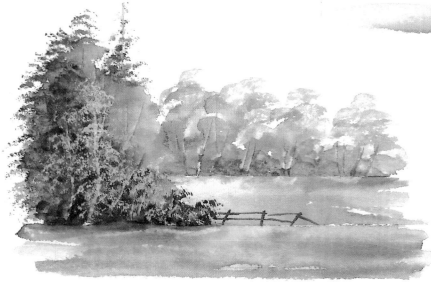

This 'doodle' illustrates the effect of recession. To achieve recession, I painted the distant trees in cool colours, using the quick downward strokes described in the first example. The grouping in the foreground was then painted. To add the necessary detail to this grouping, I used a stippling action. You could try using a piece of crumpled tissue or grease-proof paper dipped in paint or a natural sponge to achieve this – see demonstration opposite. Test the effect on scrap paper first.

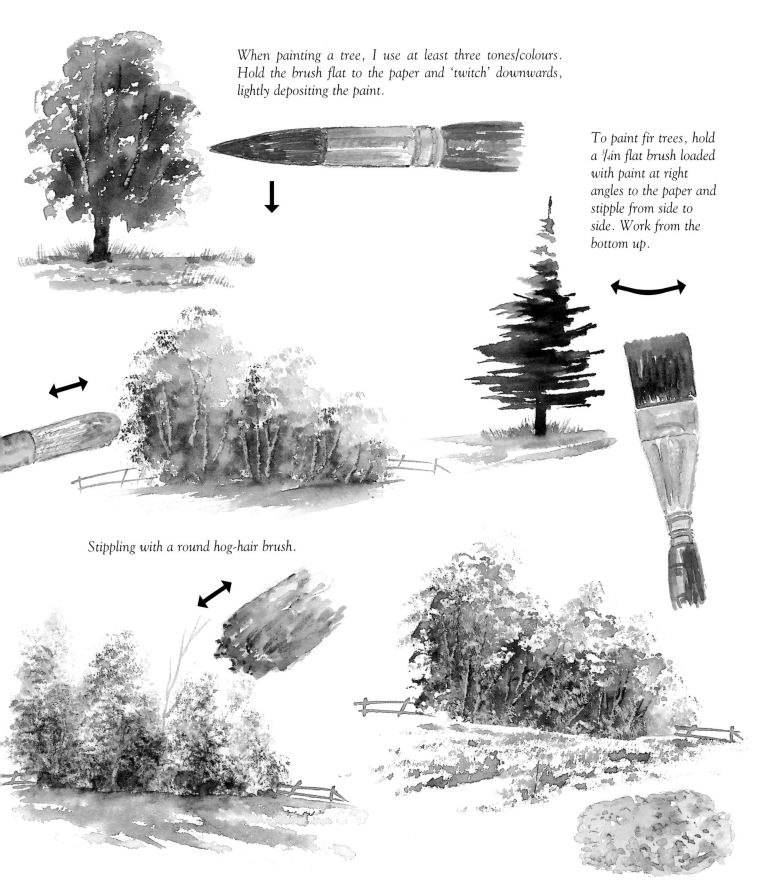

When painting a tree, I use at least three tones/colours. Hold the brush flat to the paper and 'twitch' downwards, lightly depositing the paint.

To paint fir trees, hold a ¾in flat brush loaded with paint at right angles to the paper and stipple from side to side. Work from the bottom up.

Stippling with a round hog-hair brush.

Stippling with a crumpled piece of grease-proof paper.

Using a sponge to create texture. Don't squeeze the sponge as you stipple.

PAINTING TREES *Close up*

I never complete a painting in one sitting. I prefer to look at it over a two-week period so I can make any changes I feel are necessary.

These changes may involve removing paint, or adding highlights or more detail. In **Autumn Gold** I added depth to the foliage of the trees in the right foreground, to help balance the painting.

Before I began this painting, I positioned a piece of $^3/_4$in wide masking tape a third of the way up the paper, the top of the tape representing the distant water-line.

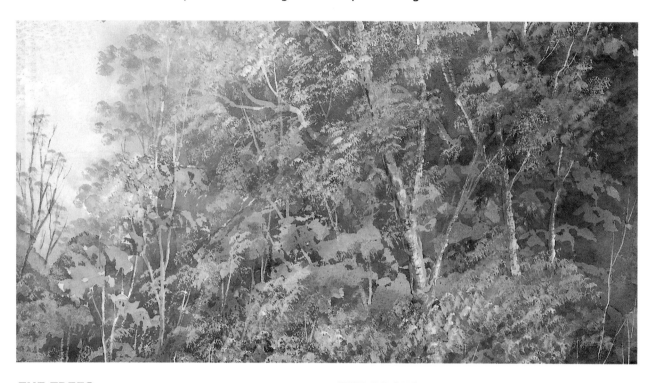

THE TREES

First, I used a sliver of mounting card dipped in masking fluid to draw in the main shapes. For the fine lines, I used a cocktail stick dipped in the masking. The next stage was to mask the tree foliage. The technique I used was to crumple a piece of grease-proof paper, dip it in the masking fluid and stipple in the shapes of the foliage. (Crumpled tissue or plastic wrap can also be used. Which you choose will depend on the size of the deposits you wish to make.)

Once the masking was dry, I brushed in washes of pale green, Raw Sienna and Payne's Gray/Alizarin Crimson, tilting my board to allow the colours to blend.

I removed the masking when the washes had dried. I brushed pale washes of the colours into the white areas to make the foliage of the trees look realistic. Some detail was painted into the tree structures using a rigger brush. When this had been done, I carefully removed the masking tape.

THE ROCKS

The rocks are an important feature in this painting. I drew them with a paint brush dipped in Raw Sienna in order to establish the shapes. When the paint was one-third dry I took a size 6 brush and added Burnt Sienna and Alizarin Crimson mixed with Payne's Gray. I moved the paint around to create structure. When I needed to remove surplus colour, I used a paper tissue shaped to a point.

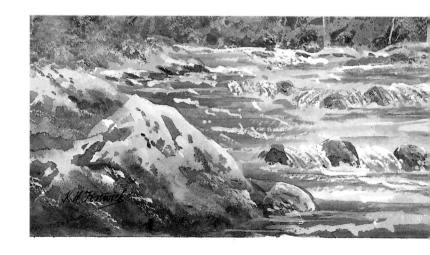

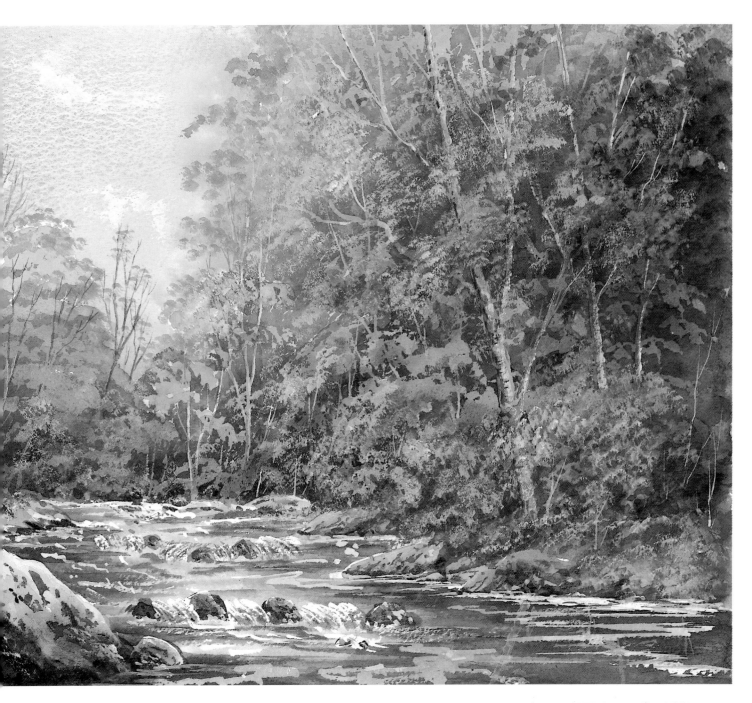

THE WATER

Masking fluid was applied to the areas between the rocks, where the fast-flowing water was to be painted, and to other areas of white water. When the masking was dry, I used a hake brush to paint the whole of the river area, washing over the masking. When this was dry, the masking was removed.

The hairs of a size 14 round brush loaded with Payne's Gray were spread between thumb and forefinger to fan the hairs to create fine lines. Then I painted the fast-flowing water between the rocks, using quick, light directional strokes of the brush.

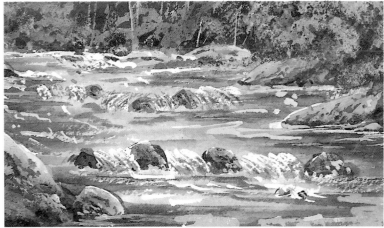

PAINTING TREES *Project*

I was asked to paint this **Constable Country** for a TV programme. The challenge was to represent the great variety of trees, bushes and vegetation effectively, given the size of the painting (22in x 15in). I chose to stipple with a sponge, which enabled me to build up the detail and make a pleasing final picture. If I'd chosen unwisely, and opted instead to use a brush, I would have had to apply a great number of brush strokes and the painting could have ended up looking lack-lustre as a consequence.

1. DRAWING AND PREPARATION

I used a water-soluble crayon for the initial drawing. A pale blue wash was applied to paint the sky and when this was dry I painted a rough representation of trees by stippling with a sponge dipped in various tones of green. Washes were applied to the river bank, made by mixing Raw Sienna, Cerulean Blue and Permanent Sap Green. When using the sponge, don't squeeze it or you will create surplus water, resulting in blobs of paint rather than an open effect to represent the foliage effectively.

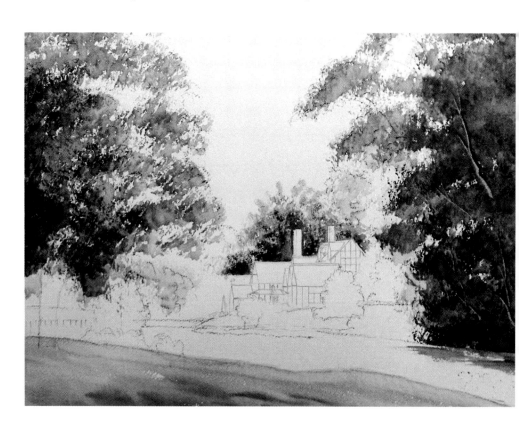

2. THE FOLIAGE

More detail was added to the trees, using a stippling action with the sponge, and the initial shape of the bushes defined. I used a blue-green for the tree on the left, and added more yellow to produce a softer green for the tree on the right. The colour mixes used for the foliage were made from combinations of Cerulean Blue, Cadmium Yellow Pale, Raw Sienna and Payne's Gray, to darken the mixes to add depth to the foliage. A touch of Alizarin Crimson/Burnt Sienna was used to paint the flowers in the distance. (A technique called negative painting was used in the representation of the chairs on the patio. This is when you paint around the object you wish to preserve.)

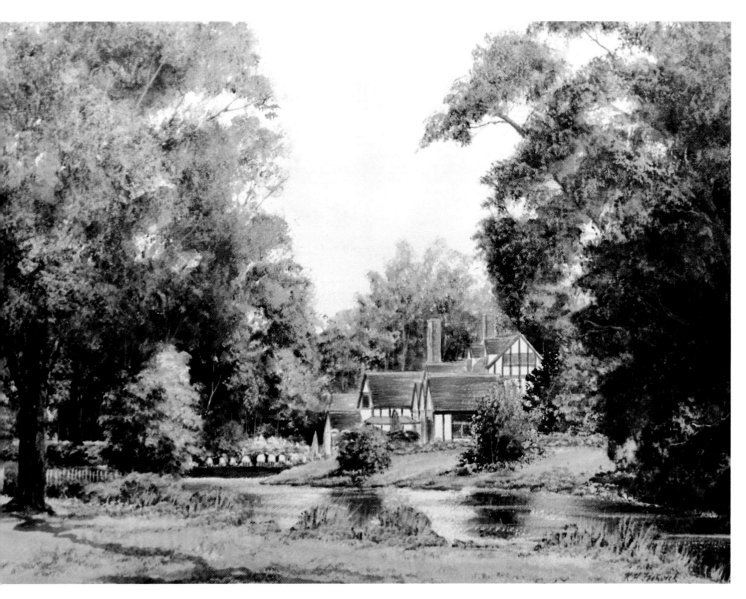

3. ADDING DETAIL

The roofs of the buildings were painted using a mix of approximately 20 per cent Burnt Sienna/80 per cent Alizarin Crimson. The tree structures were painted using Raw Sienna/Burnt Umber mixes. For the trunk, I applied a Raw Sienna wash and while this was still wet added darker tones of Burnt Umber.

Now let's bring the painting together. To shape the distant trees and the middle distance bushes, I stippled with a hog-hair brush loaded with mixes of soft green and yellow greens. The reeds were painted on the river bank. Detail and shadows were added. Finally, the water and reflections were painted wet-into-wet and the white fence on the left side was painted using a dry white water-soluble crayon.

These are the colours you will need

| Payne's Gray | Cerulean Blue | Alizarin Crimson | Raw Sienna | Burnt Umber | Cadmium Yellow | Permanent Sap Green | Burnt Sienna |

PAINTING TREES *Project*

Successful artists continually try new ways of capturing the landscape in paint. They experiment with new methods, try new tools and look at their work critically. Some of their new practices will be successful, others will fail. Either way they will learn and through their endeavours extend the range of techniques available to them when painting a landscape.

I have painted the scenery shown in **First Snow** in all seasons, in this case in autumn. The light covering of snow contrasts with the colours of the autumnal foliage. I used a number of unconventional techniques in this painting, as you will see.

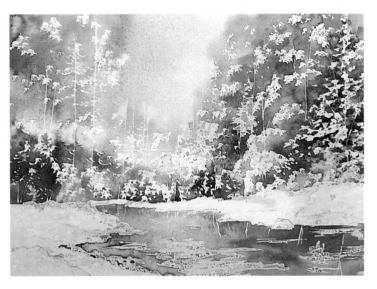

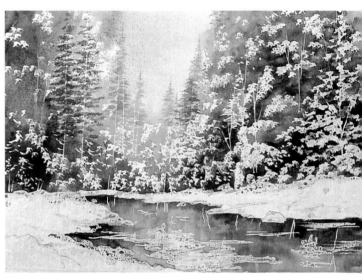

1. DRAWING, MASKING, POURING PAINT
I drew the outline of the trees and the river bank with a dark brown water-soluble crayon. Using a piece of crumpled grease-proof paper dipped in masking fluid, I stippled over the trees to create impressions of foliage.

I masked some of the tree structures, using a cocktail stick dipped in masking fluid. I also applied masking to the river banks and light areas in the water, this time by means of an old brush.

Then I mixed several ample washes in saucers. The colours I chose for this were Cadmium Yellow Pale, Cerulean Blue, Payne's Gray/Alizarin Crimson and Permanent Sap Green. After inclining the board at about five degrees, I poured the washes over the paper. Cadmium Yellow Pale was poured first, followed by Cerulean Blue in the centre, then the Payne's Gray/Alizarin Crimson mix, and finally Permanent Sap Green over the trees on the right-hand side of the painting. Burnt Sienna was brushed into the trees on the left side.

While the washes were still wet I tilted the board until it was almost vertical to allow the washes to blend, run down the paper and off the bottom of the board. Sometimes the masking restricted the flow of paint, so I used a round brush to push paint around the masking. An occasional spray of clean water from a spray bottle encouraged the flow of paint. Surplus paint was removed with an absorbent tissue. The board was then laid flat. When the paint was almost dry I used a hairdryer to make sure the paint was completely dry.

2. FURTHER POURING, ADDING DETAIL
Using a size 14 round brush loaded with the Payne's Gray/Alizarin Crimson mix, I added depth to selected areas of the foliage. These darker tones give the foliage depth and structure and achieve recession in the painting.

I added the fir trees by stippling with a ¾ in flat brush loaded with Permanent Sap Green. For the distant firs, I added more water to lighten the colour. I used a hair-dryer to dry the paint completely.

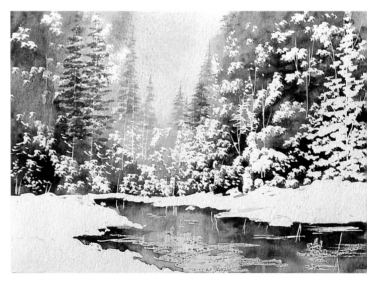

3. REMOVING THE MASKING
Using a putty eraser gently, I removed the masking from the trees and river banks. I find the masking adheres to the eraser and comes off the paper cleanly.

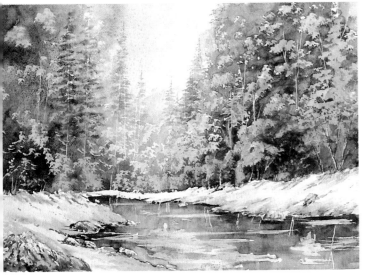

4. GLAZING AND PAINTING THE WATER

Washes of Cadmium Yellow Pale, Raw Sienna, Burnt Sienna and Permanent Sap Green were applied to the areas of white paper to add a range of autumn colours to the foliage. Subtle hints of colour used for the foliage were transferred to the river banks. I felt the inclusion of the rocks helped to balance the painting. Finally, I removed the masking from the water.

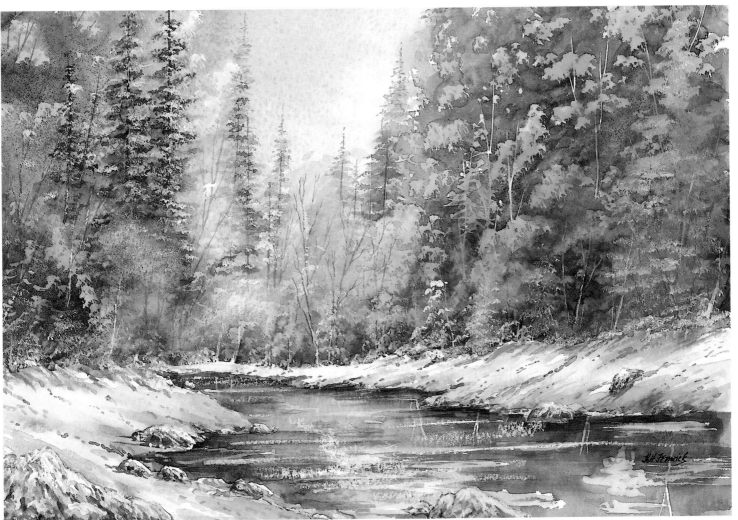

5. BRINGING THE PAINTING TOGETHER

This is the time to add the final touches. I have included a rock in the foreground to improve the composition, and also darkened the fir trees on the left-hand side with a Payne's Gray/Alizarin Crimson glaze. Using a chisel-ended hog-hair brush dipped in white gouache, *a light dressing of snow was painted on the fir trees and a few bushes along the top of the river banks.*

Finally, I softened the end of a white water-soluble crayon in water and then used it lightly to create sparkle in selected areas of the river.

PAINTING TREES *Creating tree structures*

Several techniques can be used to paint tree structures. Some of the most interesting involve the use of a palette knife. In addition to this technique, you will also find advice on how to use permanent masking medium to create structures and how to add interest to an underlying structure.

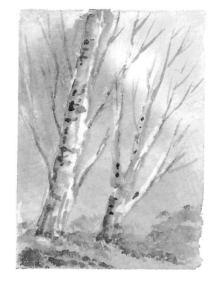

USING A PALETTE KNIFE

After painting the background, I left the paint until it was approximately one-third dry and then, using a palette knife, moved the paint about to create the tree structures.

You will need to purchase a knife and practise with it before you try this technique in a real painting. The width of the structure of your tree will depend on how you use the knife: press down hard with the whole edge of the knife and you will get a trunk that is the width of your knife; press lightly and you will produce narrower widths; use the corner or edge of the knife and you'll produce thin lines.

USING PERMANENT MASKING MEDIUM

The tree structure here was painted using permanent masking medium. With traditional masking fluid, several stages would be involved. Permanent masking medium is mixed with colour, the subject painted and left on the paper. When dry it will repel light washes.

In stage one the masking medium was applied to create the tree structure. In stage two detail was added to the trunk with the masking medium, and when this was dry a background wash was applied.

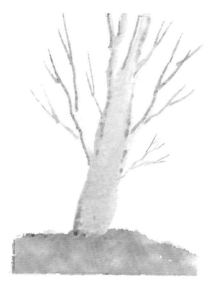

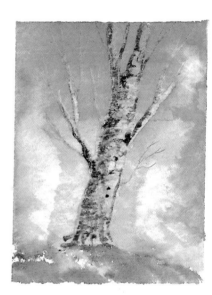

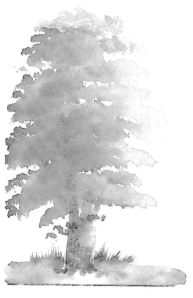

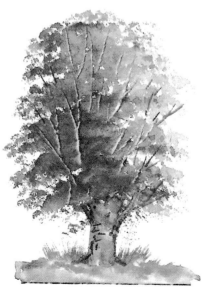

CREATING REALISM

In the first stage of this painting I used Raw Sienna for the under-painting, to determine the shape, and while this was still wet over-painted with a deeper green. To add depth to the tree some Payne's Gray was over-painted when the first stage was approximately one-third dry.

Finally the trunk was painted and some branches were scratched in using a palette knife. Realism and depth have been achieved by ensuring that the tree is darker on the inside.

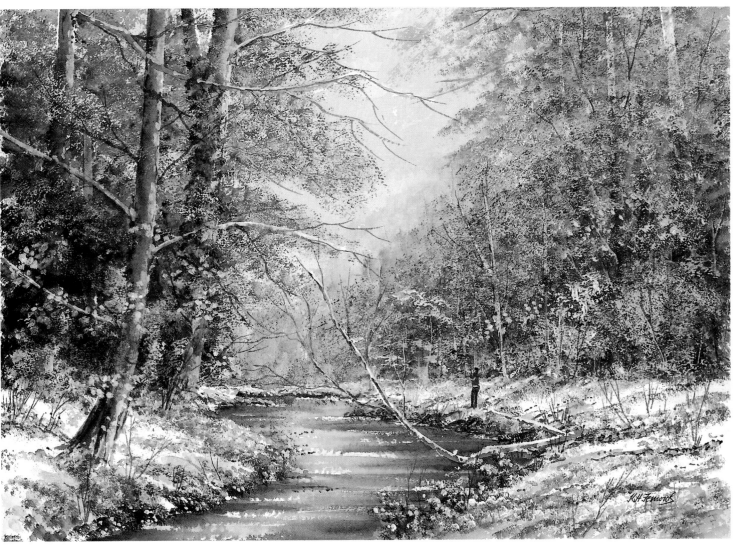

In this painting I used permanent masking medium to paint in the tree structures, the palette knife to scratch out branches and also texture medium to give the foliage texture. The texture medium added to the colour makes the paint thicker and less watery. Note how I have achieved the impression of recession by painting the distant trees in lighter tones.

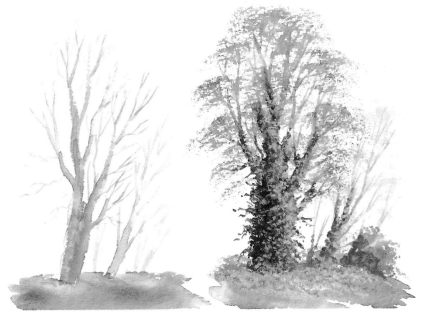

FOLIAGE AS STRUCTURE

In this example the trunks have been over-painted to represent ivy. This is simply painted by adding a dark under-painting and, when this is dry, taking a hog-hair brush, dipping this in a soft green mixed with a little white gouache or acrylic paint and stippling in impressions of leaves.

Adding tonal value

To ensure your trees look realistic and have depth, it is important to over-paint with darker toned glazes.

PAINTING ROCKS *Techniques*

The painting of rocks has always been a difficult subject for the beginner to master. In a river, they may look rounded or long and flat, as they have been shaped over the years by fast-flowing water. In a mountainous region they may appear pointed or roughly structured where they have been broken off larger deposits and have rolled down to find their own place in the landscape.

Their composition will have contributed to their structure and shape, depending on whether they are of a soft material or a hard brittle volcanic rock. Fortunately, as artists, we only have to paint them to look natural in their environment. The careful positioning of rocks in a painting can significantly improve the composition or balance. Their positioning may be determined by choosing the best vantage point from which to view the scene, or using artistic licence.

Like all subjects there are different ways to paint rocks. I always try to use the most appropriate technique, and this may depend on my mood at the time, or the size, shape or position of the rocks in the landscape.

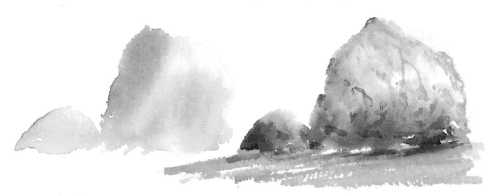

In this technique, I washed in some Raw Sienna and Burnt Sienna and while this was still wet added darker, stiffer tones of a Payne's Gray/Alizarin Crimson mix to create structure and depth. The paint was allowed to blend into the under-painting.

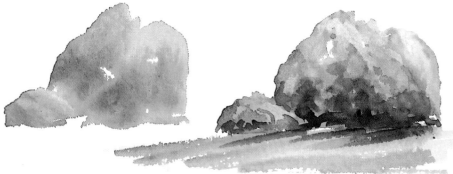

Here, I've painted an initial Raw Sienna wash and added some Burnt Sienna and darker tones of Payne's Gray/Alizarin Crimson. I used a crumpled piece of absorbent tissue to remove the paint, creating a textured appearance.

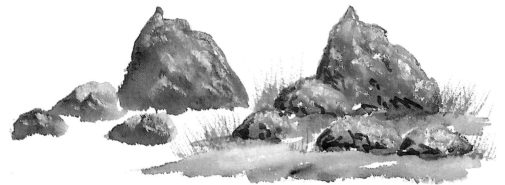

These rocks were created by initially painting their structure using a variety of dark tones and, when these were dry, adding highlights with a softened white water-soluble crayon. You can blend the white in, using a damp brush, or colour the rock by adding Burnt or Raw Sienna to the white.

Don't paint your rocks all the same shape or size and don't space them equally.

This waterfall is typical of many to be found in the English Lake District in the autumn when the water levels are high. The water is tumbling down from the mountains, washing its way through a rocky landscape.

The rocks were painted with a flat brush, using several tones and colours; I used Raw Sienna, Alizarin Crimson and Payne's Gray, and when they were dry added highlights with a softened white water-soluble crayon.

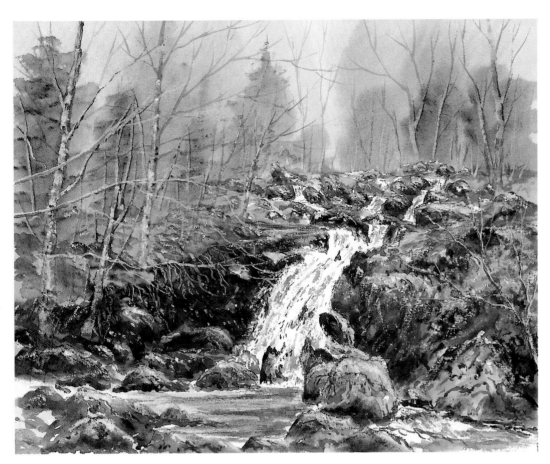

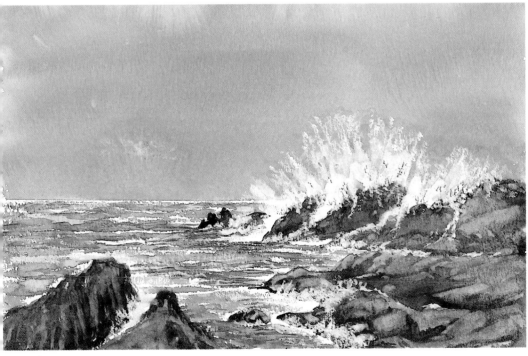

I was fascinated by the sea pounding the rocks in this sketch, completed on a painting tour of South Africa. To create the effect of the spray, I used a combination of the white of the paper and directional strokes with the side of a softened white water-soluble crayon.

Creating variation

Practise painting a group of rocks, creating variation in your grouping; make the first rock rounded, the second larger and angular, and then place an even larger and pointed rock behind the two.

PAINTING ROCKS *Design considerations – Colour mixing*

- When painting rocks, don't make them all the same size, shape or form. Don't paint them equally spaced.

- When painting rocks in water, don't forget to display shadows or they will look as if they are floating on the water.

- Rocks on land will have some type of vegetation growing around their base.

- Determine the direction of the light and add highlights and shadows.

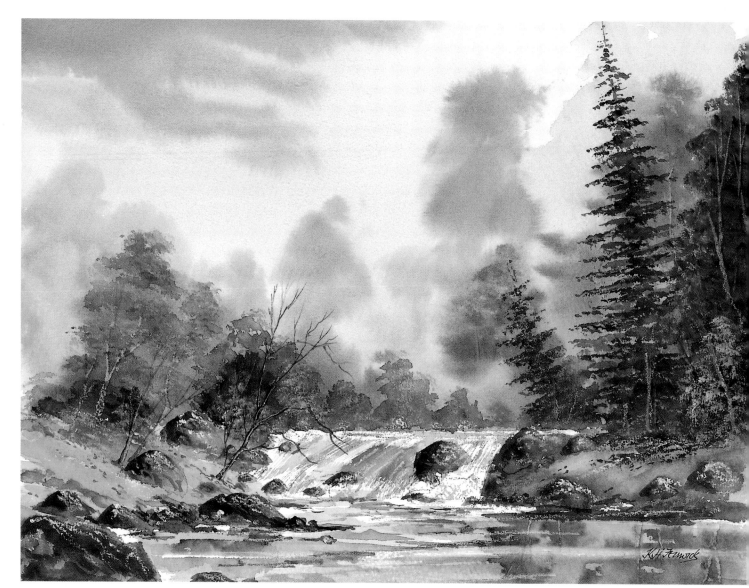

Water Rhapsody *was a waterfall I discovered on one of my walks in the wilds of Scotland. I painted the falling water with a hake brush, using fast strokes and only lightly touching the paper. Note the variation in the size, shape and spacing of the rocks – all principles of good design.*

Exercise: Using the palette knife

Using the palette knife effectively requires practice. Try this simple exercise. Cover with any dark colour an A4 size piece of watercolour paper. When the paint is less than one-third dry, see how many different shapes and effects you can produce with the knife. Now, try painting the simple rock group at the bottom of page 27.

The colour combinations shown below are those I use most often for painting rocks. Using these combinations in conjunction with varying amounts of water, I'm able to produce a wide range of tonal values.

I may also introduce other colours, depending on what I see in front of me. If, for example, the rocks are covered in lichen or moss, I will add some raw sienna or green or whatever colour I feel it is appropriate to use.

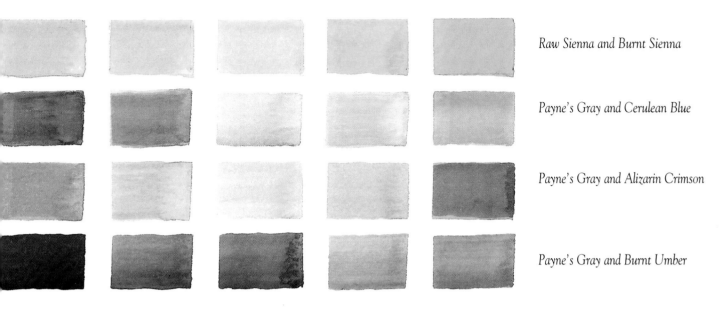

Raw Sienna and Burnt Sienna

Payne's Gray and Cerulean Blue

Payne's Gray and Alizarin Crimson

Payne's Gray and Burnt Umber

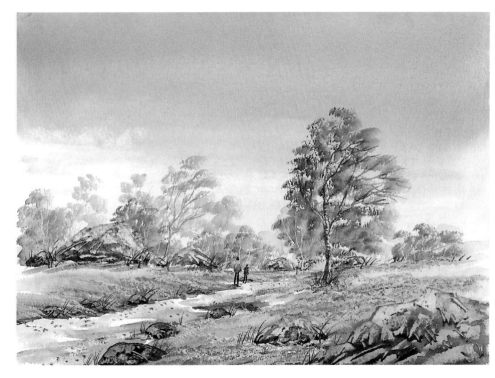

In this painting, which I call **Windblown** *because of the directional leaning of the trees, I used a palette knife to create the various rocks.*

Initially three washes were applied with the flat brush. While the paint is less than one-third dry, it is easily moved with the palette knife and the white of the paper restored. As can be seen, there is a pleasing dark shadow at the base of each stroke.

These rocks have been created by applying washes. While these were still wet, I moved the paint around with a palette knife. Some detail was added when the paint was dry.

PAINTING WATER *Introduction*

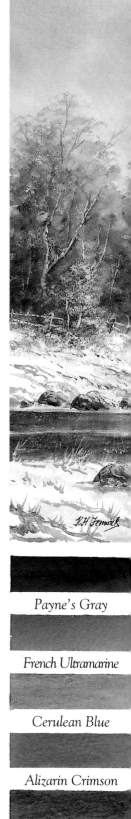

Water is a constant source of inspiration for the landscape painter, offering a choice of river scenes, waterfalls, lakes, ponds, seascapes and even puddles in a country lane. As artists we are faced with three types of water:

- Motionless – eg, a calm lake, the local pond, a puddle on a woodland path or even a rain-drenched street scene.
- Moving – eg, rivers, mountain becks, wind-blown lakes.
- Turbulent – eg, a fast-flowing waterfall, mountain beck or stormy seascape.

In this chapter we will concern ourselves with the last two types.

MOVING WATER

In a fast-flowing river or mountain beck, the whiteness of the water provides an indication of the speed of flow, particularly when the flow is restricted by rocks.

Water is best painted using the minimum number of brush strokes and a light touch of the brush. As a general rule, the faster the flow the lighter and quicker your brush strokes should be.

I like to sit by the water and observe the flow patterns, colours, tones, shadows and reflections. Squinting one's eyes to observe the flow helps establish the main characteristics. I like to produce a quick tonal study with a dark brown water-soluble crayon. When it is finished I hold it in front of me and compare it with the actual scene. If I feel changes are necessary, I will sketch them in prior to painting the scene. Too much detail makes water look fussy and unnatural. The key word is 'simplify'.

TURBULENT WATER

There is no more beautiful sight than a tumbling mountain beck or waterfall. The speed of flow and the depth of water will determine whether the water appears light or dark in tone where the water flows over a shelf or rock. When the flow is interrupted by rocks the effect will be of white water.

When turbulent water has completed its fall or been restricted by rocks, some spray may occur. The water will be darker in tone as it flows away from the base of the fall or a rocky outcrop.

I find a camera useful to capture the flow pattern, which sometimes the eye and brain have difficulty in determining.

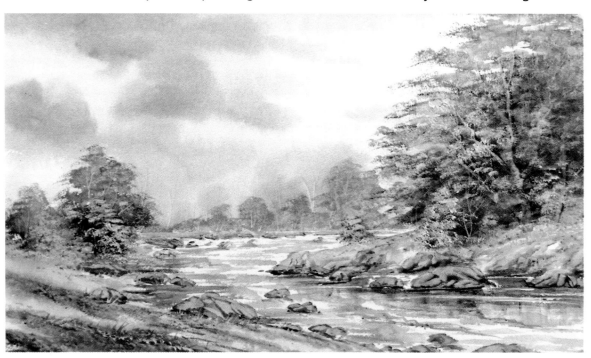

River Rhapsody *represents fast-flowing water through a rocky river bank.*

Payne's Gray

French Ultramarine

Cerulean Blue

Alizarin Crimson

Burnt Umber

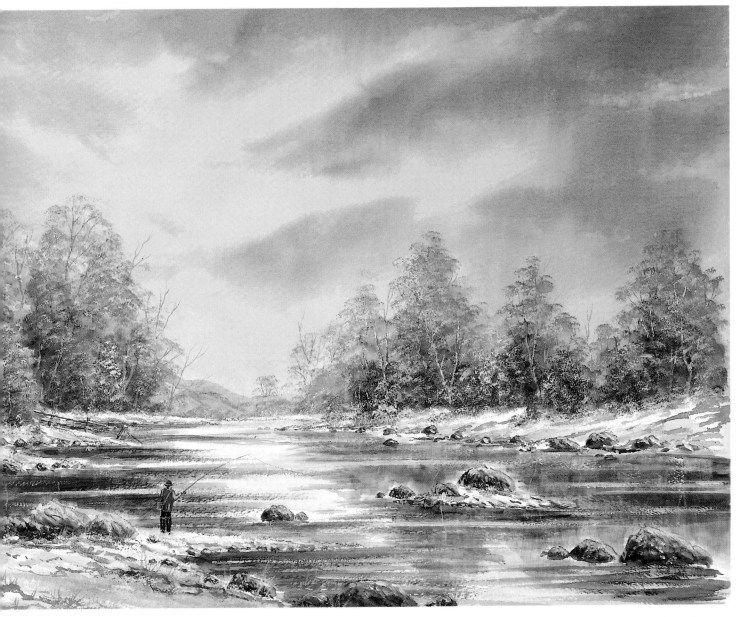

Reflections *was a painting commissioned by an international construction company. The reflections are mirror images of the reflecting objects and the sky colours repeat on the surface of the water.*

REFLECTIONS

Reflections will appear blurred in moving water, and as a mirror image in still water. Where there are reflecting objects, I paint the water last. A wet wash is painted followed by vertical strokes for the reflections.

It's important to understand that reflections reflect from the base of the reflecting object. For example, a large tree or building a field away may only reflect its top in the water, not its whole.

General guide to painting water

Brush strokes should follow the flow.

Shadows should be painted horizontal.

Reflections should be painted vertical.

To achieve freshness, apply quick brush strokes using a light touch of the brush.

PAINTING WATER *Techniques – Creating effects*

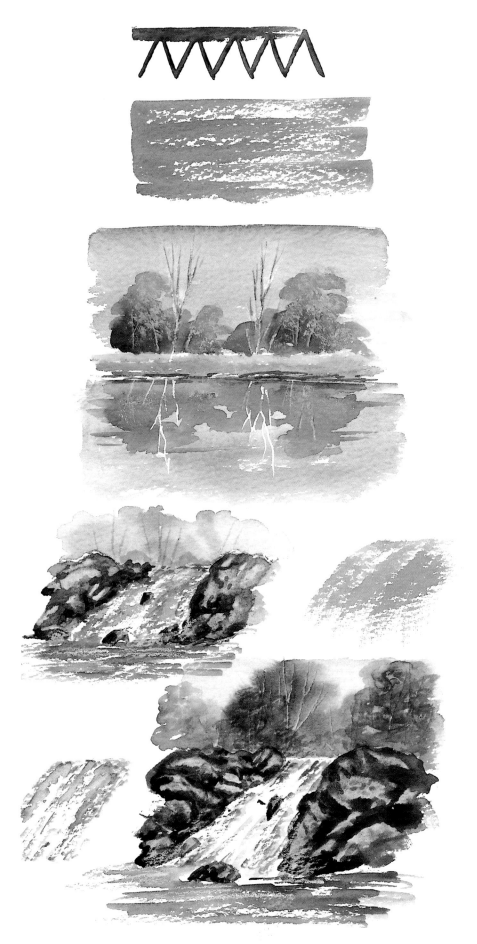

USING TEXTURE

Think of the texture of your paper as being like mountains and valleys. If you move your brush quickly and lightly across the mountain tops, the paint will be deposited on the peaks of the paper, and not be allowed time to run down into the valleys. The result is broken colour. You can use this technique to create sparkle on water – see painting on opposite page.

USING PERMANENT MASKING MEDIUM

Here I have used permanent masking medium to paint the reflections representing the tree structures. I used a cocktail stick dipped in the medium to draw the fine lines; this saves cleaning a brush. When the masking was dry the water and reflections of the trees/bushes were painted over it. The masking repelled the liquid washes. With permanent masking – as the name suggests – you don't remove it.

USING A HAKE BRUSH

This water was painted using a hake brush. It's a good idea to practise first on a piece of paper similar to the paper you are using for your painting. Remember, fast strokes with a light touch are required for painting water. When you have managed to deposit the paint in this manner on your test paper, paint in the water on your landscape.

USING A RIGGER BRUSH

I've used downward strokes with the side of a size 6 rigger (a size 6 round will suffice) to paint the water. Take care, it's so easy to apply too many coats. The aim is to leave lots of white paper showing through. Just a twitch of the brush is required to achieve the light, quick strokes you need to paint water.

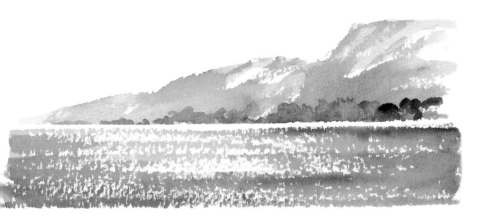

CREATING SPARKLE

Here I've demonstrated the technique discussed opposite to create sparkle on the water. The size 14 round brush or the hake should be held as flat to the paper as possible to achieve the desired effect.

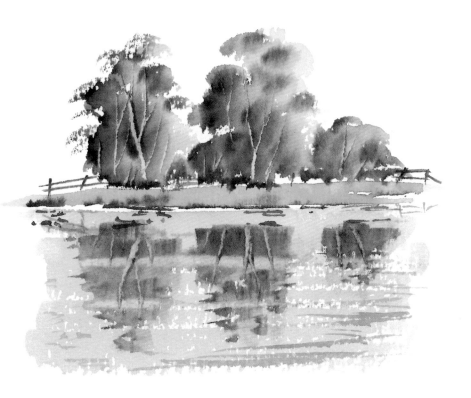

CREATING REFLECTIONS

I scratched out the background tree structures and their reflections in the water using my thumbnail when the paint was approximately one-third dry. If this technique is used when the paint is very wet, a black line will result as the scratched out areas fill in with wet paint. Timing is important.

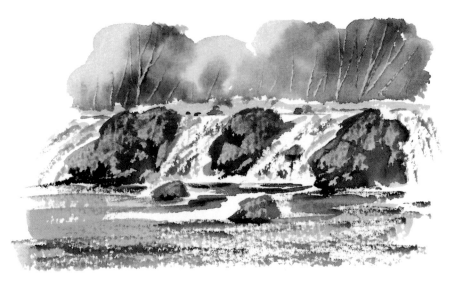

CREATING FALLING WATER

In this simple exercise, the falling water was painted using the side of a rigger brush, with the brush strokes following the angle of flow.

I painted the background trees in cool colours, wet into wet, to achieve recession and scratched out the tree structures. The texture on the rocks was created using a palette knife.

PAINTING WATER *Colour mixing*

Problems in colour mixing usually result from using a palette that isn't large enough for the purpose. You will need a large mixing area that allows you to display the colours with adequate spaces between them. I find it essential to lay out my colours in a logical sequence – sky colours, earth colours and mixers.

I prefer tube colour to the small hard pans of colour because I like to begin each painting with soft fresh colou

I often add a little Alizarin Crimson to brighten th mix or a little Burnt Umber to darken the mix. Fc shadows, if you add 20 per cent of any colour on you palette to 80 per cent Payne's Gray you will be able t produce a wide range of interesting greys. Don't us black for shadows – it deadens a painting.

To achieve the correct balance of colour you will need to experiment with mixing colours. The mixes shown here are just some of the variations possible using the colours shown below.

The colours shown opposite are mixes for water.

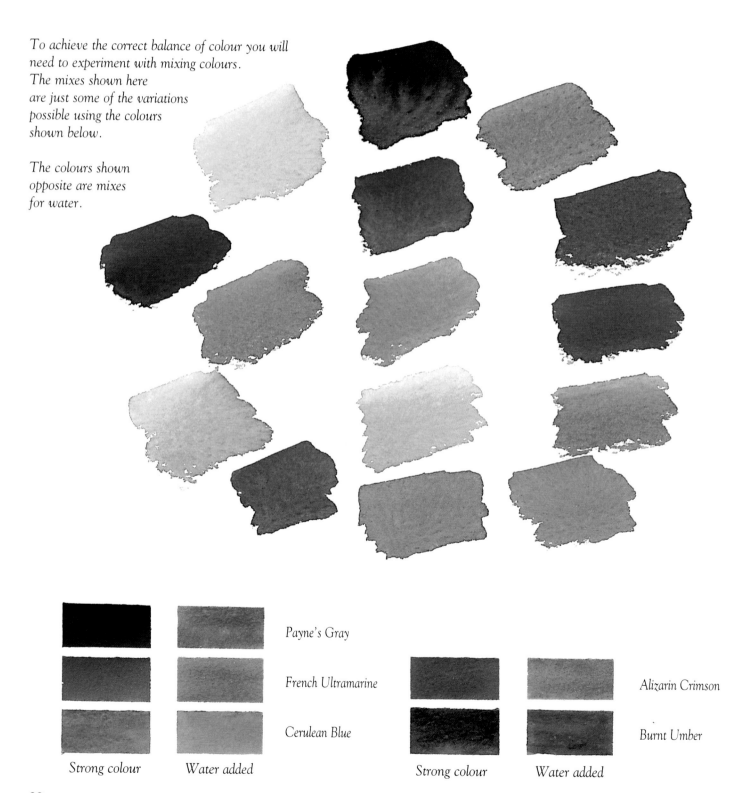

		Payne's Gray
		French Ultramarine
		Cerulean Blue
Strong colour	*Water added*	

		Alizarin Crimson
		Burnt Umber
Strong colour	*Water added*	

These are the colour mixes I use most for painting water; which mix you use will, of course, depend on where you are painting. Practise mixing them yourself.

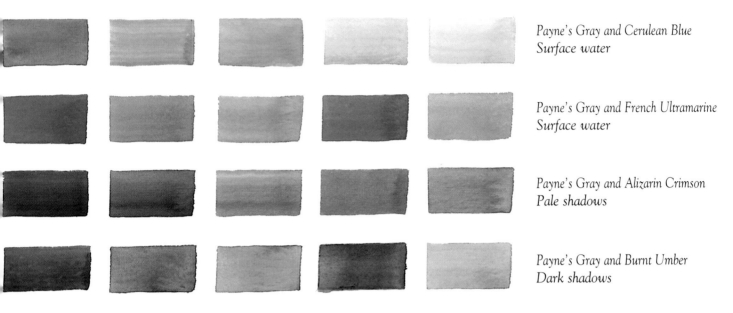

Payne's Gray and Cerulean Blue
Surface water

Payne's Gray and French Ultramarine
Surface water

Payne's Gray and Alizarin Crimson
Pale shadows

Payne's Gray and Burnt Umber
Dark shadows

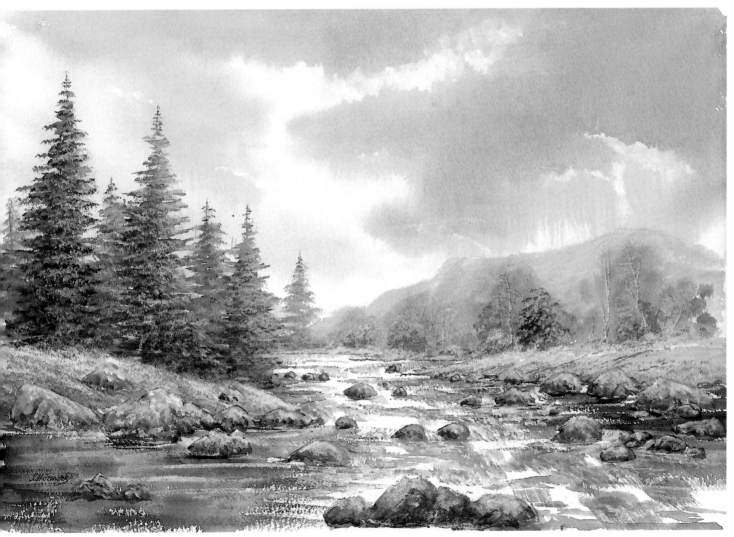

*In **Scottish Landscape** I used quick, light strokes with the hake brush to achieve the effect of fast-flowing water.*

PAINTING WATER *Close up*

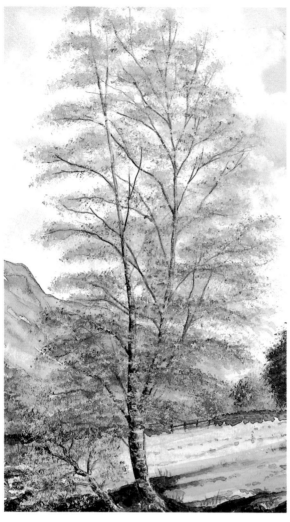

Hartsop Beck in the Lake District is one of my favourite places to paint. I made a TV programme there and to me it represents the countryside at its best. The main feature of this acrylic painting is the fast-flowing beck, which is fed by water flowing from the mountains, running through the old hamlet of Hartsop.

THE TREES

Let's begin with the tall birch tree just off-centre. Using the rigger brush, I painted its structure in pale Burnt Umber. When the paint was dry, I painted the foliage with the side of a size 14 brush using light downward strokes. The colours I chose were mixes of pale green to Burnt Sienna. When this was dry, darker tones were painted on the tree structure to achieve a more realistic effect.

The tree on the left was darker in tone. I used the same process as described above but in this instance darker tones of Payne's Gray/Permanent Sap Green were added to create depth in the foliage. To achieve a realistic impression of foliage, I stippled with a round-ended hog-hair brush loaded with a pale green.

THE ROCKS

The rocks are a feature in this painting. Various glazes of Raw Sienna, Burnt Sienna and Payne's Gray were applied to create the three dimensional look of the rocks. Acrylics enable several glazes to be applied without the worry of lifting the under-painting.

Using a 'scumbling' action the rigger brush was used to apply a little white paint mixed with raw sienna to create texture and highlights on the rocks. Think of 'scumbling' as pressing the brush to the paper and 'wiggling' it about to deposit paint in various patterns. Finally I used the rigger brush to paint in a few cracks or fissures in the rocks and added a few darker shadows.

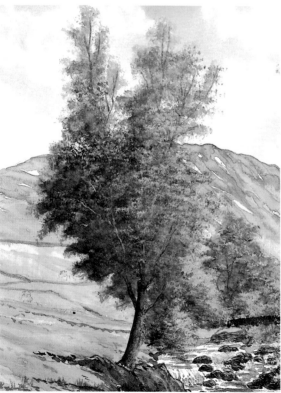

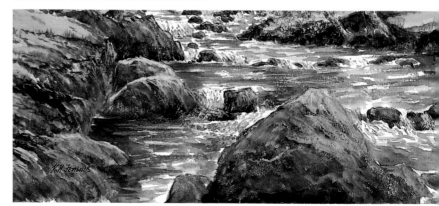

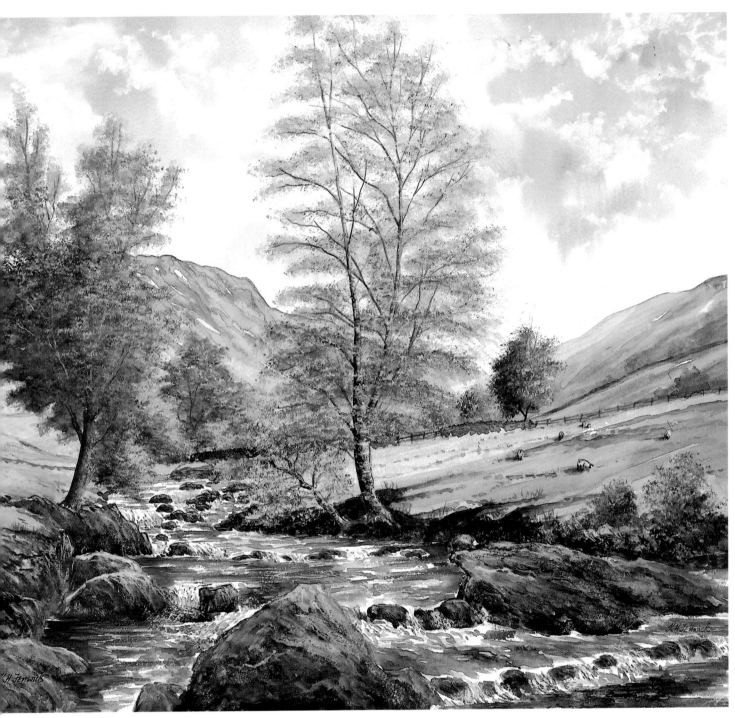

Hartsop Beck – *a fine example of fast-flowing water in an area of outstanding natural beauty.*

THE WATER

Initially, I used the side of the rigger brush to paint the flow lines between each of the rocks, representing flowing white water. The next stage was to paint some medium tones as horizontal lines to fill in the expanses of water between each level of rock. For this I used the hake brush. Finally, I added some darker tones to each side of the river bank to represent reflections and give depth to the water.

The colours used to paint the water were Cerulean Blue and Payne's Gray in various mixes and tones. The water area was painted in less than three minutes. In order to achieve recession in this painting, more white of the paper was left uncovered in the distant water.

PAINTING WATER *Tonal values – Design considerations*

An understanding of tonal values is the most important factor in painting a successful landscape. It's important to clarify one's thinking and approach to the painting before contemplating applying paint to paper. Many of my students splash paint on without careful planning and design. A black and white photocopy of one of their paintings will show how far they have got it wrong, as the copy will reveal the same tone throughout.

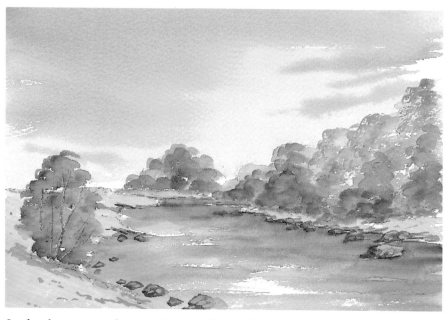

In this first attempt by one of my students, there's little variation in tonal values between the trees in the foreground and those in the distance. The cloudless sky does little to balance the right-hand tree grouping. The rocks appear as if they are floating on the water and there's no variation in colour. There's insufficient detail to interest the viewer.

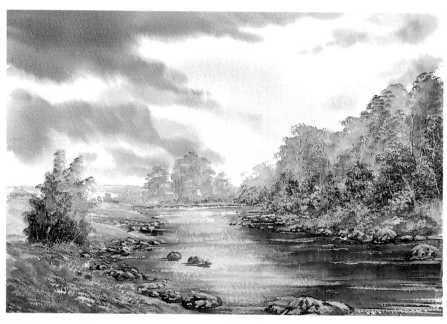

This is a more interesting representation than the previous painting because of the tonal variation in the various elements. I painted the clouds on the left darker in tone to balance the more detailed tree grouping on the right, and also added darker values to the trees for depth. Notice too the shadows in the water and under the rocks, and the texture in the foreground. Note that the distant trees have been painted in lighter tones to achieve recession.

So, what should they have done? To begin with, I always produce small tonal sketches of the scene from different vantage points to determine which of them is going to produce the best composition and to establish the lights and darks in the painting.

These sketches are very simple, about 3in x 4½in in size, and produced in a few minutes with a dark brown water-soluble crayon. I can draw with the crayon and then spread the paint with a moist brush.

DON'T ALWAYS PAINT WHAT YOU SEE

My students always look puzzled when I explain to them why they shouldn't necessarily paint what they see. Let's give you an example. I'm sitting on the river bank and on my left there's a specimen tree, and on the right bank there's a group of trees going into the distance, following the river as it bends to the left behind the tree. All the tones in the foliage appear to be the same.

Now, I know from experience that if I paint what I see, the painting won't work. What I have to do is paint the tree on the left bank twice as dark as it appears.

The foreground tree on the right bank needs to be painted two-thirds as dark as the specimen tree. As the trees become more distant, you need to paint them gradually lighter in tone until the tree farthest in the distance passes behind the dark specimen tree on the left. This will achieve a sense of recession in the painting, leading your eye into the scene, along the river and out behind the specimen tree.

I used to spend hours visiting exhibitions, studying the work of other artists who painted similar scenes to mine. I asked myself why their paintings looked better. I soon realized that it was the distribution of light and dark values that made their paintings a success. If you follow this approach, I'll guarantee your paintings will improve significantly.

CHECK-LIST

• Water and reflections are constantly changing with the weather.

• A slight breeze will have a significant effect on the surface of water. Don't attempt to alter your painting as changes occur. Create a picture in your mind and paint from that.

• It's a good idea after painting the sky to carry the colours down into the water. When reflecting elements are involved in the landscape, paint the water in last, followed by their reflections.

• River banks are seldom straight like a road. Paint them to look 'ragged' for realism, adding shadows from the bank to give depth to the scene.

• Don't forget the principles of linear perspective. When painting the river banks, they should be wider in the foreground, gradually becoming narrower or vanishing in the distance.

• Paint the surrounding terrain first, allowing space for the water, then paint this in using the minimum of quick, light, positive strokes, leaving some paper uncovered to represent white water.

EXERCISES

1. Practise using a hake brush to paint tumbling water. Aim for quick strokes that lightly touch the paper. You will have to add darker tones but don't forget to leave lots of white paper showing through.

2. Practise the techniques for creating sparkle on the water (see pages 30–31).

3. Practise wet-into-wet reflections and, using a paper wedge, wipe out a wind line.

4. There's no substitute for painting outdoors. Sit by a river or waterfall, soak in the atmosphere, squint your eyes to identify the main patterns of flow and produce tonal studies from different vantage points.

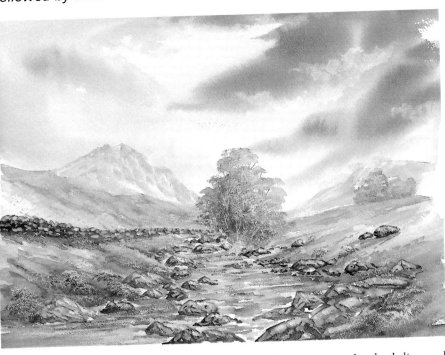

This painting of a Lakeland beck embraces some of the points in the check-list, and the techniques you'll practise in the exercises. I used fast, light strokes of the hake, which was loaded with varying tones of Payne's Gray/Cerulean Blue, to create the effect of fast-flowing water.

3. THE W

Painting t
this painti
1½ in hal
Gray/Ceru
this techn

A WORD

When pre
you draw
example,
tricky for

Excessi
paper you
surface. It
drawing c
then – us
transfer it
to take a

How to transfer an outline drawing of a completed painting onto watercolour paper

The technique I'm about to tell you about is not a substitute for learning to draw and should only be used until you are competent at drawing.

1. Take a black and white photocopy of the painting to the size required.

2. Using a soft pencil (6B), scribble across the back of the photocopy.

3. Position the photocopy over your watercolour paper, trace around the outline and key features using a biro or 2H pencil.

4. Remove the photocopy. The image will have transferred to your paper ready for you to apply paint.

PAINTING WATER *Project*

The landscape shown in **Tumbling Water** is typical of those found in the Yorkshire Dales National Park. It isn't my intention to show you how to paint the scene as a whole but rather to concentrate on how to create the effect of fast-flowing water as it tumbles over rocks. The land in this part of the country is quite peaty which colours the water a warm Sienna as it runs over the rocky shelves.

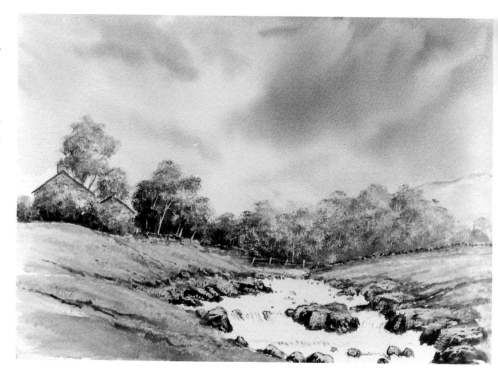

1. ESTABLISHING FLOW PATTERNS

As always, my approach was to complete a tonal study to determine the most appropriate vantage point. This study helped me to clarify my approach to the painting, to identify the most important flow patterns and to establish the light and dark values. The water is so complex, you need to simplify.

Using the hake brush, I initially made a few marks to identify the principal flow patterns. I used a rigger brush to paint in a few small rocks using a weak Payne's Gray wash.

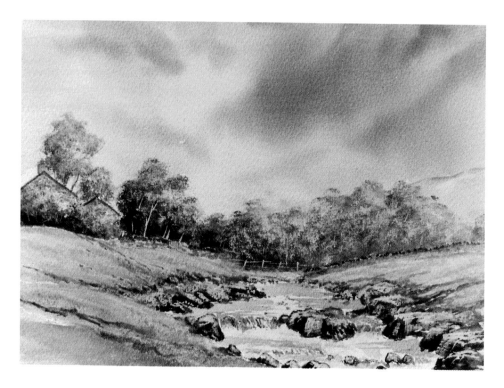

2. BUILDING UP THE WATER

Using horizontal strokes with the side of the size 14 round brush and a weak Cerulean Blue mix, I painted in the water, being careful to leave some of the white paper uncovered.

The next step was to give more definition to the water flowing between the rocks, using the corner of the hake brush loaded with a Payne's Gray/Cerulean Blue mix. To create this effect you need just 'twitch' the brush; in other words, depositing the paint by using fast short strokes. (It's a good idea to practise on a similar type of watercolour paper first until you are happy that the paint is being deposited as you wish.) A weak Burnt Sienna was brushed in to represent the colour of peaty water.

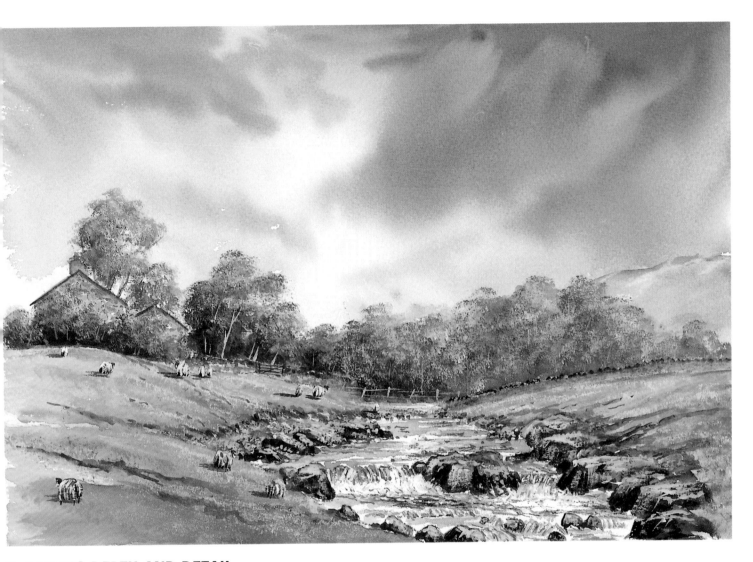

3. ADDING DEPTH AND DETAIL

All that's left to do is to paint in some darker tones of Payne's Gray to add depth and detail to the water flowing away from the base of the rocks.

It's inevitable, when painting water, that you will get carried away and overdo it in places. In my case, I hadn't left sufficient white paper showing through between the rock on the right and the bank. This can easily be corrected by dipping a hog-hair brush into clean water and washing off the paint, then dabbing the area with a tissue to restore the white paper. Simpler still is to try the technique I have used here: take a white water-soluble crayon and add a few white streaks.

Adding interest

You will notice that I have positioned a few sheep in this painting. They make such a difference to the foreground and add life to the painting.

These are the colours you will need

Payne's Gray

Cerulean Blue

Alizarin Crimson

Raw Sienna

Burnt Sienna

Permanent Sap Green

White water-soluble crayon

TREES, ROCKS and RUNNING WATER *Linear perspective*

In this painting I want you to take note of how I have ensured linear perspective. First the brush strokes are directed towards the vanishing point; secondly, the river bank is shaped so that it is wider in the foreground and narrow in the distance; and finally the trees gradually diminish in height as they recede into the distance. By these principles of linear perspective the eye is led into the painting, through to its furthest point where the river vanishes out of sight round the bend.

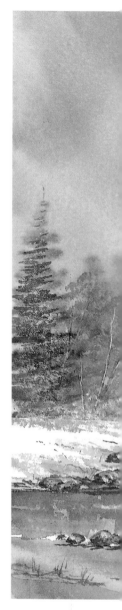

SHAPING THE RIVER BANK

If you make your river banks a feature of your painting it will look more interesting. Don't paint them as straight lines. The bank will have land jutting out into the water and inlets where the water, with time, has washed away the soil. In this example you'll see that I've painted in some dark shadows or reflections to give the water depth and interest. Adding a few rocks also helps to create a pleasing effect.

THE ROCKS

The shadows on and under the rocks were achieved by applying darker tones of a Payne's Gray/Alizarin Crimson mix with a ¾ in one stroke brush. When the paint was one-third dry, I moved it around with a palette knife to give the rocks a realistic look. When the painting was completely dry, I used a softened white water-soluble crayon to add the effect of a little snow.

THE WATER

The reflections from the trees were painted wet into wet, using downward strokes with a flat brush loaded with the tree colours (Raw Sienna, Burnt Sienna, Payne's Gray, Alizarin Crimson, Permanent Sap Green and Burnt Umber). The wind lines were made by removing some of the paint by means of a tissue shaped to a wedge. Burnt Umber applied with a rigger brush was used to paint the reflections of some of the trees.

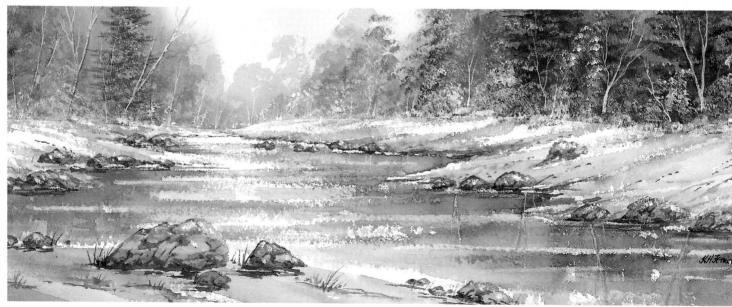

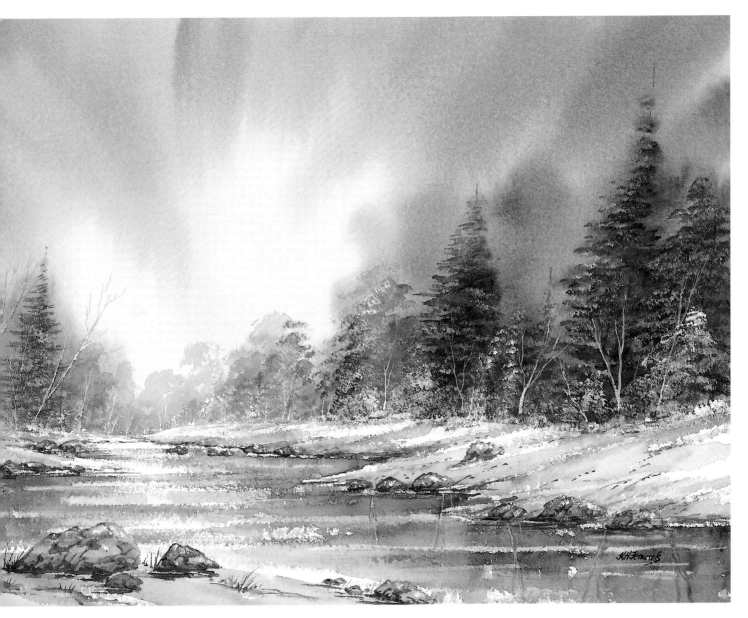

THE TREES AND BANK

The trees lining the bank vary in shape, height and variety. Two firs stand out, however. They were painted with the rocking, stippling technique described on page 15. The remaining trees/bushes were painted using a size 16 hog-hair brush with a stippling action. The snow on the trees was added by stippling with white acrylic paint. The distant trees have been loosely painted in very pale, cool colours to achieve recession in the painting.

Some of the sky colours (Payne's Gray, Alizarin Crimson, Cerulean Blue) were introduced into the bank by wetting the white of the paper with clean water and letting the subtle touches of colour blend in.

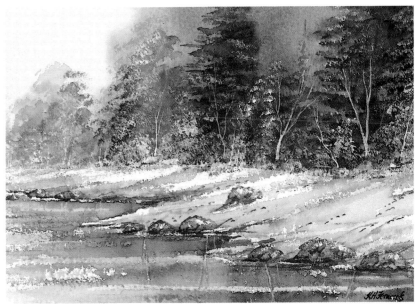

This atmospheric landscape, which I call **Seldom Seen**, provides an opportunity to show a range of more unusual techniques. The more successful artist will be continually experimenting with new techniques to improve their work. I hope you find this method of working stretches your imagination.

MASKING AND POURING PAINT

After drawing a simple outline I applied masking fluid by means of a piece of crumpled grease-proof paper and lightly dabbed it on the areas of foliage that I wanted to preserve. By shaping a piece of grease-proof paper to a point, I masked the river bank and areas of the water. For fine lines in the water and the tree structures, I used a cocktail stick dipped in masking. These aids were disposable, saving me the task of cleaning brushes.

Generous washes of Raw Sienna, Permanent Sap Green, Cadmium Yellow Pale, Payne's Gray and a Payne's Gray/Alizarin Crimson mix were mixed in saucers in readiness for pouring when the masking had dried.

The paper was inclined at an angle of 10 degrees, Cadmium Yellow Pale poured on the right-hand side and Permanent Sap Green on the left-hand side. The paper was then tilted until it was almost vertical, allowing the colours to blend and run off the bottom of the paper.

While the paint was still wet, I used a tissue shaped to a wedge and stroked upwards from the base of the fall, removing paint, to represent water spray.

The wind lines were created by wiping a wedge-shaped tissue across the water. The paint was then allowed to dry.

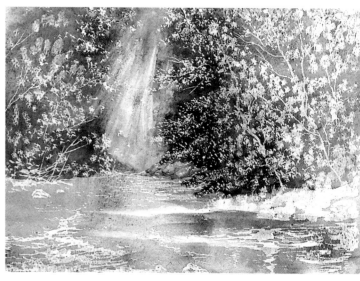

ADDING DARKER TONES

A further pouring of Payne's Gray/Alizarin Crimson was completed to darken the area around the waterfall. The wash was allowed to run off the bottom of the painting to darken the water.

When the wash was dry, I used a putty eraser to remove the masking fluid.

CREATING TEXTURE

A Cadmium Yellow Pale wash was poured down the right-hand side to brighten the foliage and a sap green wash down the left to darken the foliage. The paint was allowed to dry. This was followed by re-wetting selected areas of the right-hand foliage with clean water, using a spray bottle. Texture was created by 'spattering' with Cadmium Yellow Pale. I tapped a well laden brush across the handle to achieve this effect; how hard you tap and how far away you are from the paper determines the size of the droplets. Where the paint hits dry paper, distinct highlights will result and

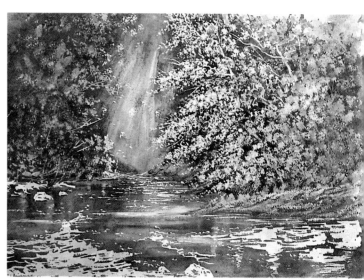

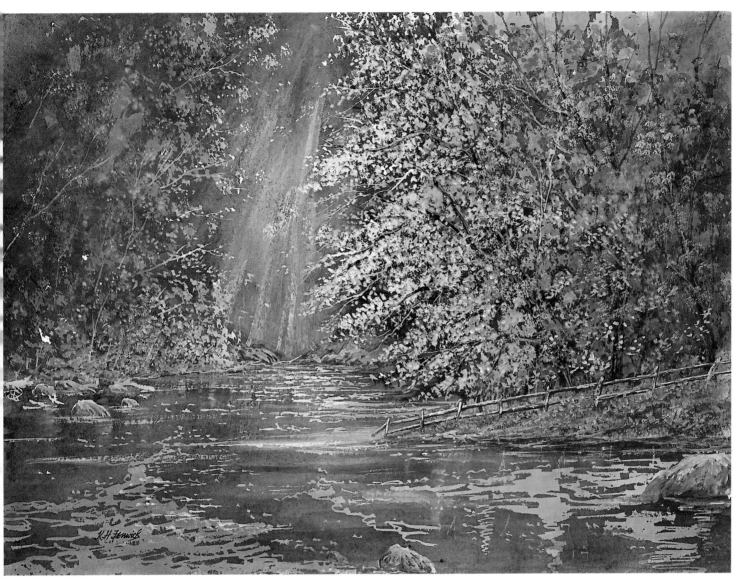

where it hits dampened paper the effect will be blurred images and a softer texture.

I applied a Raw Sienna wash to the river bank and the whole of the water area. Texture to represent rough grass was painted on the bank and a purple wash applied to selected areas of the water to darken the tonal value, creating a pleasing shadow.

FINAL TOUCHES
To complete the painting, further detail was added to the foliage by applying a lighter Cadmium Yellow Pale/Raw Sienna mix. A Payne's Gray/Alizarin Crimson glaze was applied to the left-hand area of water and to the rocks. Finally, I felt that the addition of the fence would improve the composition.

These are the colours you will need

Payne's Gray Alizarin Crimson Raw Sienna Cadmium Yellow Pale Permanent Sap Green

TREES, ROCKS and RUNNING WATER *Close up*

I chose **Sunburst** for you to study because it shows background light shining through the trees and reflecting on the surface of the water.

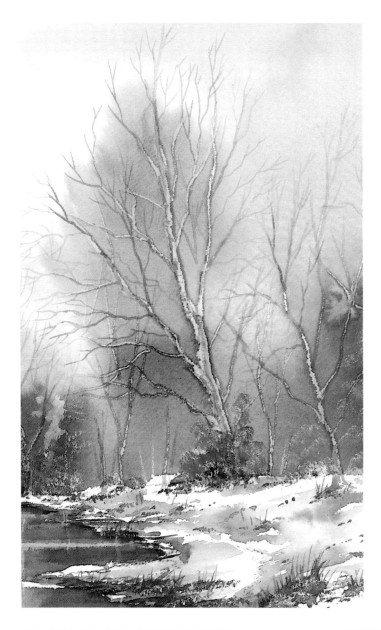

THE BACKGROUND

The background has been painted wet into wet to create recession in the painting. Snow is very rarely pure white. It reflects cloud shadows and effects of the light. Raw or Burnt Sienna can be used to give the snow a warmer look, as in this painting. For a 'cold' snow scene I use pale blue shadows.

To paint the sky area, I applied various tones of Cerulean Blue and immediately painted in Payne's Gray/Alizarin Crimson, Cadmium Yellow Pale and Burnt Sienna washes to selected areas. I added darker tones of Payne's Gray/Permanent Sap Green to represent the bushes in the background. To achieve this soft, atmospheric effect, I had to work quickly, while the sky was still quite wet.

Once the shine had gone from the paper, the tree structures were scratched out with a palette knife. Timing is important here. If you scratch out when the paint is very wet the area will fill in and turn a darker tone but if you time it just right, you will reveal the white paper. Here, I have achieved a mixture of both – light areas of trunk with darker edging that gives the trees authenticity.

THE BANK AND REFLECTIONS

Notice the pleasing shape of the bank and how subtle colours and tufts of grass have been added for interest. After shaping the bank, I added darker reflections in the water. For these I used a mix of Payne's Gray/Permanent Sap Green and at the edges added a little Burnt Sienna.

I used the tissue wedge technique to indicate wind lines in the water.

The snow on the trees – and particularly the bush – was stippled in, using a hog-hair brush dipped in white acrylic paint. I scratched in the tree structures with my thumb-nail.

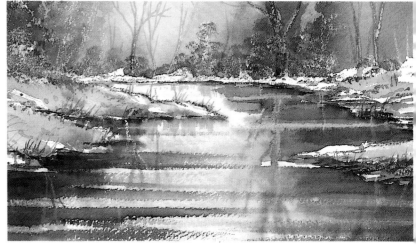

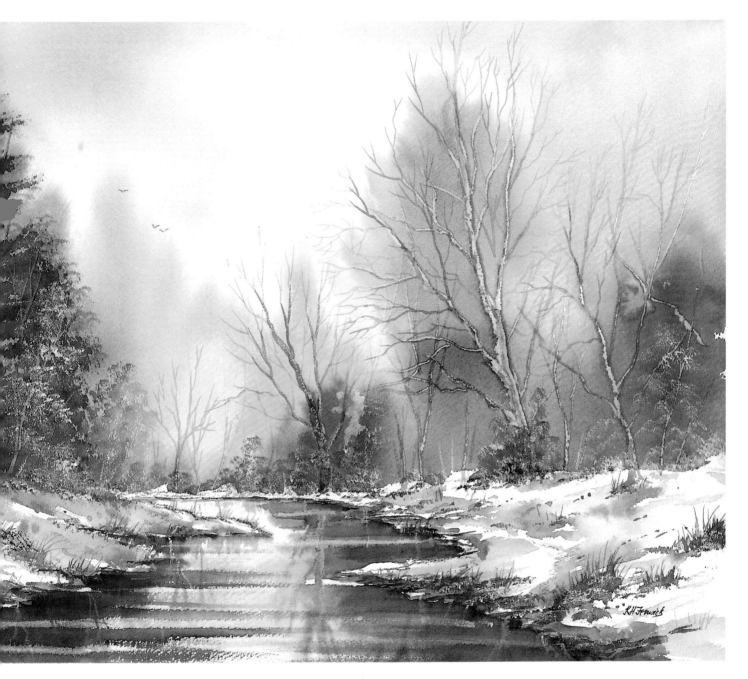

THE FIR TREES

painted an initial weak Permanent Sap Green wash as background. The fir trees were painted with a flat brush using a rocking action (see page 15). For the trees, I used strong mixes of Payne's Gray/Permanent Sap Green and added a little Burnt Sienna in elected areas to provide variation.

It was important to paint darker tones for he tree group on the left-hand bank to take he eye along the river and round the bend. The painting would have looked flat if I had painted this group in lighter tones.

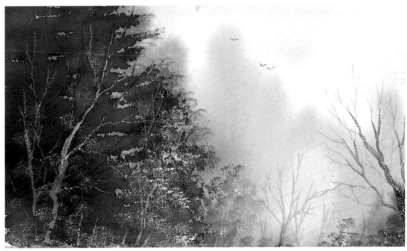

47

PORTRAIT OF THE ARTIST

Keith Fenwick is one of the UK's leading teachers of painting techniques. He enjoys a tremendous following among leisure painters, who flock to his demonstrations and workshops at major fine art and craft shows.

Keith is a Chartered Engineer, a Fellow of the Royal Society of Arts, an Advisory Panel member of the Society for All Artists and holds several professional qualifications including an honours degree. He served an engineering apprenticeship, becoming chief draughts-man, before progressing to senior management in both industry and further education. He took early retirement from his position as Associate Principal/Director of Sites and Publicity from one of the UK's largest colleges of further education in order to devote more time to his great love, landscape painting.

Keith's paintings are in collections in the United Kingdom and other European countries, as well as in the United States, Canada, New Zealand, Australia, Japan and the Middle East.

Keith runs painting holidays in the UK and Europe, seminars and workshops nationwide and demonstrates to up to 50 art societies each year. Keith can be seen demonstrating painting techniques at most major fine art and craft shows in the UK. He has had a long and fruitful association with Winsor & Newton, for whom he is a principal demonstrator.

Keith's expertise in landscape painting, his writings, teaching, video-making and broadcasting ensure an understanding of student needs. His book *Seasonal Landscapes* has proved very popular, as have his 20 best-selling art teaching videos, which have benefited students worldwide. He is a regular contributor to art and craft magazines.

Keith finds great satisfaction in encouraging those who have always wanted to paint but lack the confidence to have a go, as well as helping more experienced painters to develop their skills further. He hopes this series will be a constant companion to those wishing to improve their skills and experiment with new ways to paint the landscape.